touch

GRAPHIC DESIGN WITH TACTILE APPEAL

FERDINAND LEWIS and RITA STREET

ROCKPORT
PUBLISHERS

GLOUCESTER MASSACHUSETTS

First published in the
United States of America
BY
Rockport Publishers, Inc.
33 Commercial Street
Gloucester, Massachusetts
01930-5089
Telephone: (978) 282-9590
Facsimile: (978) 283-2742
www.rockpub.com

ISBN 1-56496-799-9
10 9 8 7 6 5 4 3 2 1

Design: MATTER
Cover Image: MATTER

Printed in China

dedication

The authors would like to thank Nick
Chase and the indefatigable Caryl Bloch.
Thanks to all the designers for
1) going out on the tactile limb to make
these pieces in the first place and 2)
being patient while we badgered them
to explain the unexplainable.

Speaking of patience: Special thanks to
Kristin Ellison, editor and saint.

F.L. AND R.S.

touch

CONTENTS

There's a new artist running around our office, and we have him to thank for our interest in tactile graphics. Although his focus—like that of many graphics professionals—lies mainly in 2-D, when he really wants to make an impact he adds a touchable element to his design. For instance, the January page of his most recent calendar featured a snowman made from flour paste, and his cardboard celebration of Groundhog Day sported a pop-up rodent and real dirt.

His best tactile graphic, though, is The Flat Stuff Holder—An 8.5" x 11" (22 cm x 28 cm) piece of cardstock folded lengthwise, illuminated by totemic drawings, with hand-scissored slots along the spine. Even though Caleb is only seven, he recognized the trouble we have wrangling the dozens of business cards that collect on our desks. So he made this "holder for all that flat stuff" as a utilitarian self-promo, knowing that every time we reached for it we'd think of him. What Caleb didn't know is that his work would cause us to examine the very idea of tactility and its ability to promote an idea, product or event.

Poking our noses into studios around North America and Europe, we soon realized that—first graders notwithstanding—tactile graphics are the exception rather than the rule. For practical reasons, few designers can allow tactile work to lead their aesthetic—corporate clients are often intimidated by that unruly third dimension of tactility, and tactile pieces are sometimes hard to produce in quantity. In most cases, tactility appears only when conditions are right, and those conditions vary wildly. Still, tactility is graphic design's trump card, and tactile designs often become the most prominent pieces in a portfolio.

Having collected a cross section of current tactile graphics ranging from a rubber media kit to inflatable packaging to an aluminum postcard, we began to wonder where this genre might be headed in the near future. MIT's Touch Lab kindly introduced us to the science of haptics, which not only maps the neurology of touch, but is also developing technology that allows us to feel digital objects and textures. It seems inevitable that an entire haptic language will one day enter design nomenclature, which could provide an eye + hand interaction more satisfying than has heretofore been possible. The final section of this book is a roundup of the current work in haptics as it applies to digital graphic design.

The digital future may be mind-blowing, but what inspired us the most is the plain old sense of *fun* that designers get out of creating high-touch graphics. Joy-in-making translates into joy-in-using, which pretty much describes the spirit of tactile design.

Of course, our little in-house designer has been showing us that all along. We're definitely going to give him a raise.

Ferdinand Lewis and Rita Street

introduction

foreword

The power of tactile graphics goes way back...

Visual artists are tactile people. We see and experience the physical world and never cease to be fascinated by it. No doubt this fascination dates back to Neolithic times when early man began to understand the impact he could have on the physical world. At some unmarked moment around ten thousand years ago, someone placed a hand against a cave wall and blew pigment over it, using the mouth as an airbrush. The mark left still bears witness to his existence: The ultimate personalized trademark applied to a most permanent location.

Artists and designers love physical objects, especially if they've had a hand in making them. When people experience an art object tactilely, actually hold it in their hand, they understand something of what the artist was thinking when they created it.

When designers have the time and budget to experiment with materials, truly exceptional artifacts are created. The 1995—1996 catalog for Art Center (see pg.174), designed by Rebeca Méndez, was surely such an artifact. The catalog embodied the notion that digital media was challenging printed analog objects, and at any moment the catalog might completely deconstruct into an interactive entity outside the control of its creators. The piece was about what it might become rather than what it was. A profound grasp of materiality was a crucial factor in the success of this catalog, and every material aspect of it was considered from a highly conceptual point of view.

At Art Center, graphic design students are exposed to many tactile experiences. Two artists who continue to inspire are James Cornell and Marcel Duchamp: Cornell with his mysterious boxes and Duchamp with his famous *Box in a Valise*. Such objects bring us back to childhood, when we kept our eclectic treasures in cigar- or shoeboxes. Occasionally, students will be given the freedom to make a special object where material cost is considered secondary and material expressiveness becomes paramount. Given that freedom, students often create objects of such tactile exquisiteness that your first response is, "I want that," even when you're not sure what "that" is. Such objects seem to contain magic that the viewer must possess.

Most graphic designers receive countless promotional items in the mail from paper companies, design organizations, and other designers. The things we keep are often the most tactile: the strange little box sent years ago containing all the designers named Michael in San Francisco, the marvelous catalogs produced for Takashimaya in New York, or the wonderful House of Cards by Charles and Ray Eames. These are not simply beautiful things; they carry the imprint of their originators. They refuse to be thrown away with the junk mail and paper cups. They resonate with the excitement that we all feel when carefully selected materials are pulled together into an object charged with artistic inspiration and eloquent thinking. The resulting visual event continues to hold our attention, to demand our contemplation, and to leave us with a little mystery and magic, not unlike the image of the hand in that cave left long ago.

Ramon Munoz,
DEAN OF STUDENTS AND FACULTY,
ART CENTER COLLEGE OF DESIGN

EVENTS

"Design in general is thought to appeal to the sense of sight and to the intellect, because a lot of design is seen at a remove: on a screen, on a poster or billboard. But handmade work conveys a sense of personal contact between the sender and the recipient, because it's not something you just look at but also have to handle. By simply adding an element on top of the paper, for instance, the piece becomes an object. Even if it's printed in some aspect, [the tactile element] makes the printing seem more personal, as if it were saying, 'This was made just for you.'

It's only appropriate for certain pieces, of course. In a magazine, for instance, tactility would probably get in the way of the reading experience. But when it's appropriate, tactile design puts speed bumps into the process, slows people down, and handling the piece becomes an end in itself."

:STEVEN GUARNACCIA

Miss Manners, Martha Stewart, and clever designers all agree that a great party invitation calls for as much panache as the party itself. It's no wonder that the extra zing of tactility is often a designer's first choice for event invitations. In our opening chapter, we take a look at the ability of tactile graphics to draw a crowd. Whether it's a raucous grand opening, a meditative corporate retreat, or an elegant fund-raiser, event invitations featuring feel-able materials tell invitees that their host has planned something truly special. The simplicity of an invitation's mission—to entice as many guests as possible—gives artists a great deal of creative freedom. Yet, the process has characteristics in common with all tactile graphics production, such as elaborate prototypes, small print runs, and handcrafted elements. These irresistible invites are as diverse as the events they announce: a printed whoopee cushion, a pop-up Art Deco skyline, a kite in a box, even a piece of silk that requires the recipient to add water to observe the graphic's full effect. Though the parties are over, their spirits live on in these inviting pieces of graphic art.

INVITING ART

design firm
The Greteman Group

design/art direction
James Strange,
Sonia Greteman

client
Healing Horse Therapy

materials
chipboard, metallic ink

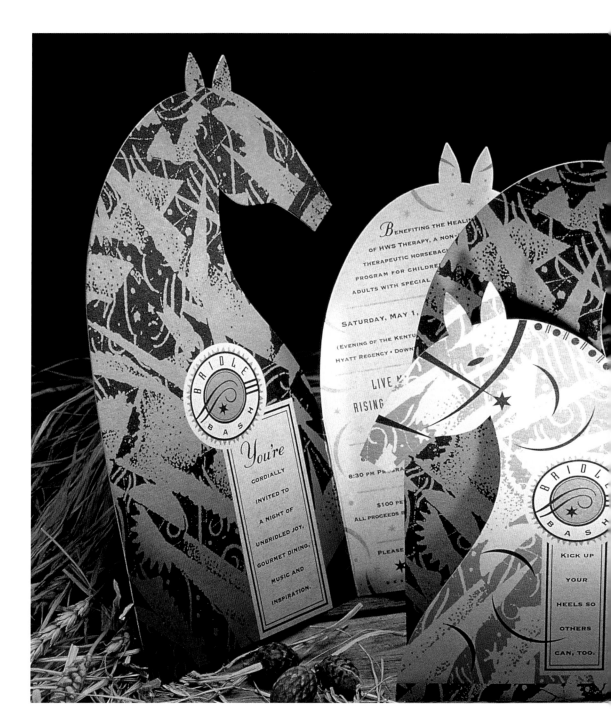

BRIDLE BASH

You're CORDIALLY INVITED TO A NIGHT OF UNBRIDLED JOY, GOURMET DINING, MUSIC AND INSPIRATION.

Benefiting the Heali
of HWS Therapy, a non-
therapeutic horsebac
program for childre
adults with special

Saturday, May 1,

(Evening of the Kentu
Hyatt Regency • Down

Live
Rising

8:30 PM Pr gra

$100 pe
All proceeds

Please

BRIDLE BASH

KICK UP YOUR HEELS SO OTHERS CAN, TOO.

Invitation to Bridle Bash

"I love this organization," Sonia Greteman says of Healing Horse Therapy, a nonprofit organization that uses horseback riding to provide physical therapy to the handicapped. Greteman chose the form of a horse head for this exquisite tactile design because, as she puts it, "they have such a magnificent shape."

Greteman created tactile ironies with her choice of materials, pairing unexpectedly rough textures with luscious metallic inks. "This was a piece of chipboard—just heavy, gritty, grubby chipboard, with two colors on front and back, copper and bronze. I like the dichotomy of the gritty with the shimmer of metallics, especially when the metallics dull down on the paper itself. Then we add another level, the crisp metallic inks on the enamel sticker."

Flexjet Pebble Beach Invitations

Once a year, Flexjet—a company that offers fractional ownership of expensive jet aircraft—thanks its Fortune 500 clientele with an exclusive event in Pebble Beach, California. Sonia Greteman and her cohorts look forward to producing the annual invite.

This piece uses tactile materials to convey the beauty of the event's northern California site. The oversized, corrugated cardboard cover speaks of earth and soil, the bamboo stick and the elastic binding suggest flora and fauna, while the gold and off-white metallic inks anticipate the beauty of a coastal sunset. The feather image was silk-screened onto the cardboard, and the informational typography—which needed to be crisp and readable—was reserved for stickers that easily adhered to the final product.

Another year's invitation required a bit of research in aerodynamic physics. The Lift Your Spirit theme connotes the breezy mood of the party's locale and spirit.

Making a miniature kite that would actually fly took some testing on the part of Greteman's creatives, who were forced to spend an entire day conducting tests out in the parking lot. (Boo-hoo, creatives.)

There's a ball of string hidden inside the box, giving the invitation's recipients every reason to go fly a kite.

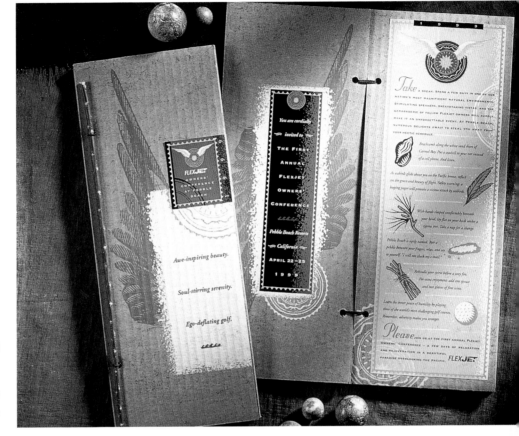

design firm
The Greteman Group

design/art direction
James Strange,
Sonia Greteman

client
Flexjet

materials
wood, corrugated cardboard, bamboo, paper, string, labels

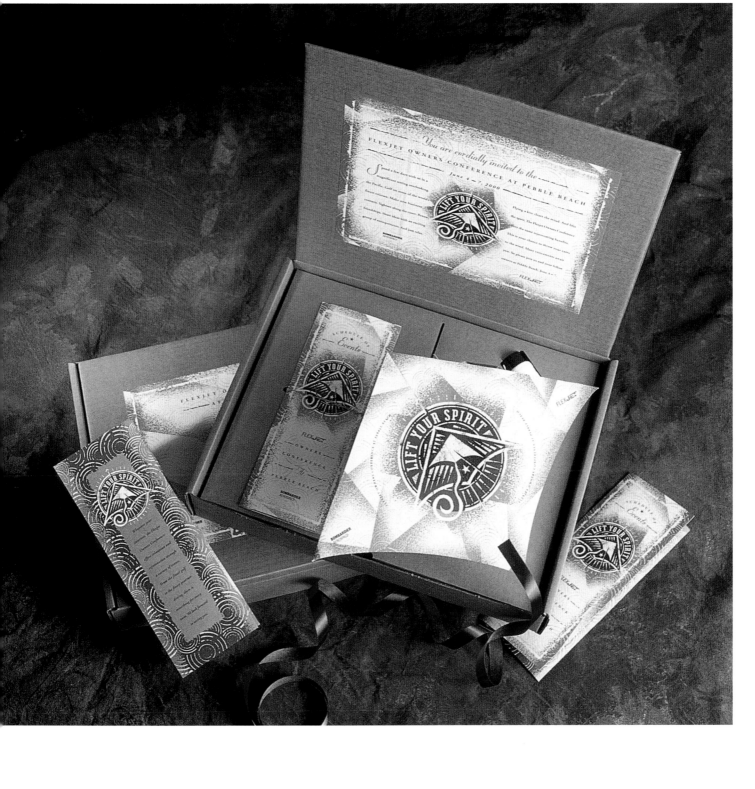

design firm
The Greteman Group

design/art direction
James Strange,
Sonia Greteman

client
Bombardier

material
die-cut cardstock

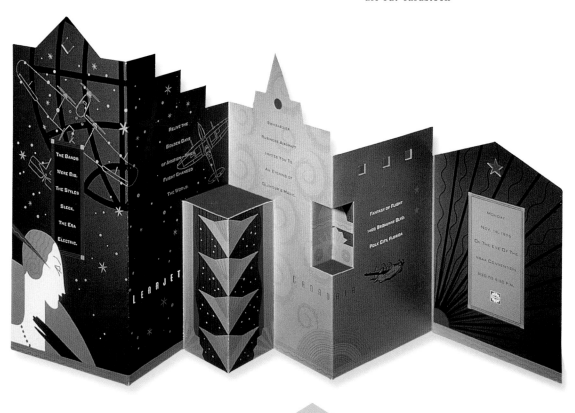

Learjet Party Invitation

When Bombardier, manufacturers of
Learjet and other business jets, decided
to throw a trade show party at Florida's
famous Fantasy of Flight Museum, they
needed an invitation as high-flying as
their aircraft. The Greteman Group, taken
with the assignment, got nostalgic about
the Golden Age of Flight and created a
pop-up skyline evoking the days when
passengers dressed up for the adventure
of air travel.

In addition to the intricate die-cuts
necessary to build three-dimensionality,
the combination of dull and gloss var-
nishes creates an almost magical sense
of depth.

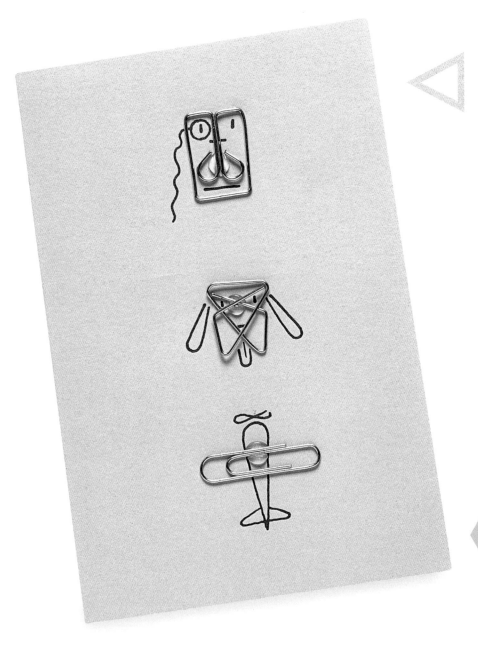

design firm
Studio Guarnaccia

designer
Steven Guarnaccia

client
Steven Guarnaccia,
self-promotion

materials
cardstock, paper clips

Ironwork Invitation

One of the Big Ideas of tactile graphics—that any object can be transformed into a graphic device—is rendered here with simplicity, humor, and office supplies by Steven Guarnaccia.

The line drawings were printed and the paper clips glued on by hand, and presto: a tactile delight. This invitation was for a Toronto gallery show of Guarnaccia's artworks and conveys the crafty wit that is one of his hallmarks.

design firm
Studio Guarnaccia

designer
Steven Guarnaccia

client
Kendall Square Research

materials
cardboard, vellum,
aluminum

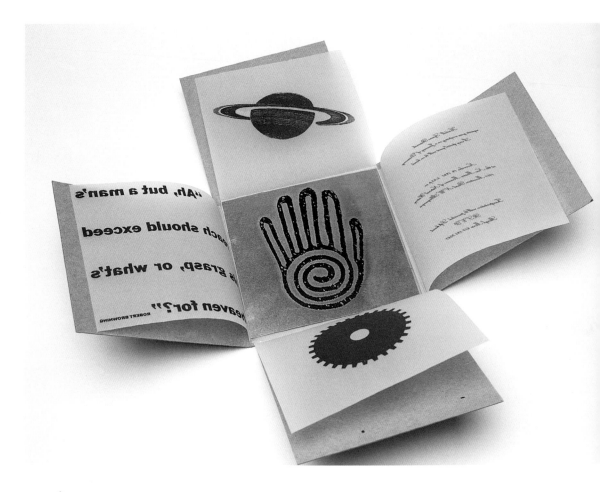

Kendall Square Research Invitation

Mind and matter converge in this design, which
confronts the recipient with a complex emblem of
interlinked icons that unfold through successive strata,
revealing the party information. Finally, the metal plate
is unearthed. "We wanted to give them an object," says
Guarnaccia, "Something that people would find appealing
in and of itself, a little gift."

"The materials and the design developed together," Steven Guarnaccia
says of this outstanding tactile party invitation. "The client had seen
our "Al U. Minium"/self-promotion (p.80) and knew they wanted to
work with tin, and the entertainment at the event was a movement
artist whose work is powerful and abstract. We were looking for
something poetic and ancient. The graphite ink has a metallic
sheen to it, and I wanted to choose imagery that would work well
with that."

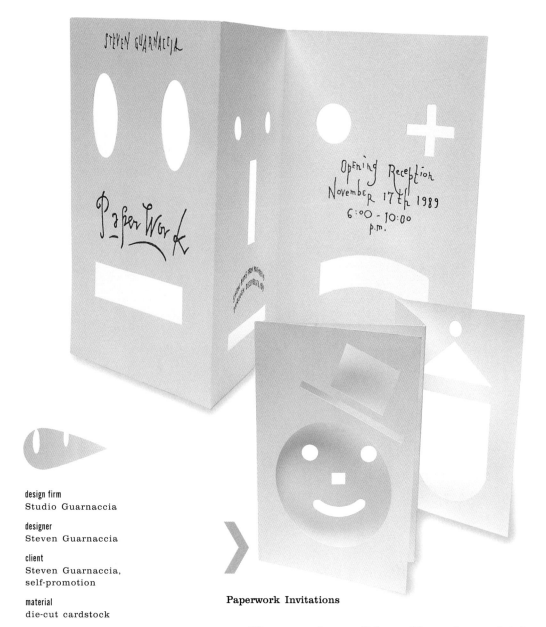

design firm
Studio Guarnaccia

designer
Steven Guarnaccia

client
Steven Guarnaccia,
self-promotion

material
die-cut cardstock

Paperwork Invitations

Whenever vendors say, "I dare ya," Steven Guarnaccia is happy to
oblige with one of his witty tactile graphics. This piece is an invitation
to a gallery show of Guarnaccia's cardboard constructions. "A lot of the
pieces in the show had to do with faces, and the gallery's printer was
looking for challenges, so it was fun to think of those folds and lots of
die-cutting. This piece led directly to work for me: The snowman card is
the blank for a Christmas card I ended up doing for a software company
in Boston."

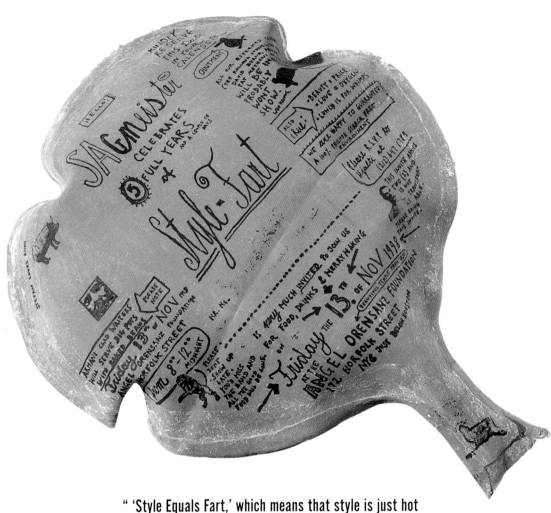

" 'Style Equals Fart,' which means that style is just hot air, that the work should be about concept."
—Stefan Sagmeister

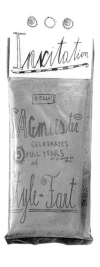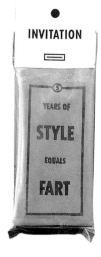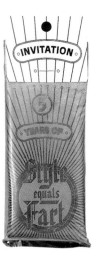

design firm
Sagmeister, Inc.

designer
Stefan Sagmeister

client
self-promotion

material
whoopee cushion

Invitation To Fifth-Year Celebration

There's no denying the whimsy of this whoopee cushion party invitation. It also illustrates why tactile graphics turn up in concept-driven designs more often than in designs based solely on style: The concept-first approach is about what a design *does* (function), rather than how it *seems* (style). Tactile elements, intruding as they do into 3-D space, imbue the message more with substance than appearance.

"At the design studio we are only secondarily interested in style and more in the content of the piece and the concept," says Stefan Sagmeister. "The style comes out of the concept. We come up with a concept first, then look at what kind of form it will take." A designer's approach should determine his client list, Sagmeister believes. "We look for clients who don't think that style is important. I don't mean that in a flippant way, I really mean it," he insists.

About the whoopee cushions, he says, "In the beginning we had a little slogan: 'Style Equals Fart,' which means that style is just hot air, that the work should be about concept."

After printing these simple party favor/invites, they were put back into their original bags for mailing.

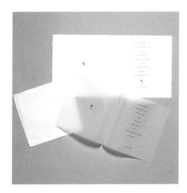

design firm
Sagmeister, Inc.

client
private client

materials
cardstock, silk, vellum

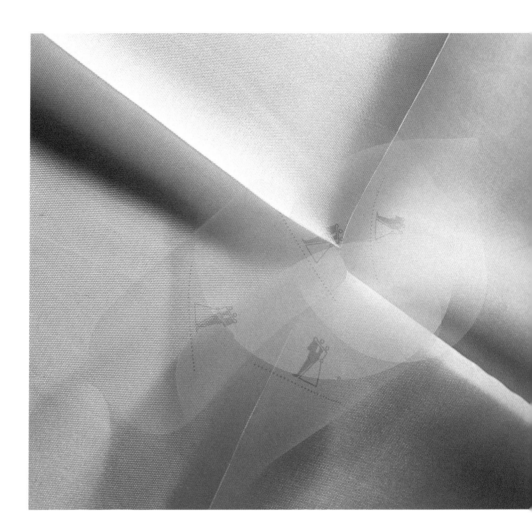

 Dancing Wedding Invitation

"I am attracted to physics because it allows you to make something that involves the viewer," says Stefan Sagmeister. "When you can do that, as a designer, you have won." He is intrigued by children's science books—"They are much more applicable to graphic design [than physics books for adults] and have a lot of little experiments in them."

Sagmeister created this tactile invitation to celebrate the wedding of two close friends. A white card is bound together with a piece of white silk and a piece of vellum. On the card is an image of a dancing couple. Instructions tell users to put the silk on water, then place the vellum on the silk. "It's a strange effect," as Sagmeister describes it. "The paper disc really dances on the silk, quite a little ballet-like effect."

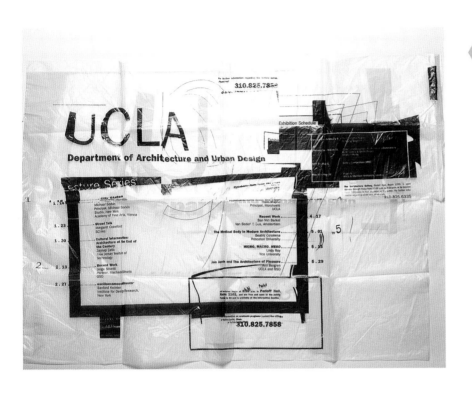

UCLA Department of Architecture and Urban Design/Lecture Series '97

Designer Rebeca Méndez drew her inspiration for this poster from the subjects covered in the lecture series for UCLA's Department of Architecture and Urban Design. "Some of the speakers focused on systems... particular to 'the city,' and other speakers touched on issues pertaining to 'the body,'" she says. "Ubiquitous to the city is garbage—an ever-changing and chaotic system." Méndez used flexography to print on garbage bags, which suggest formlessness and also "makes reference to skin and its simulation."

design firm
Rebeca Méndez
communication design

client
University of California
Los Angeles (UCLA)

material
garbage bags

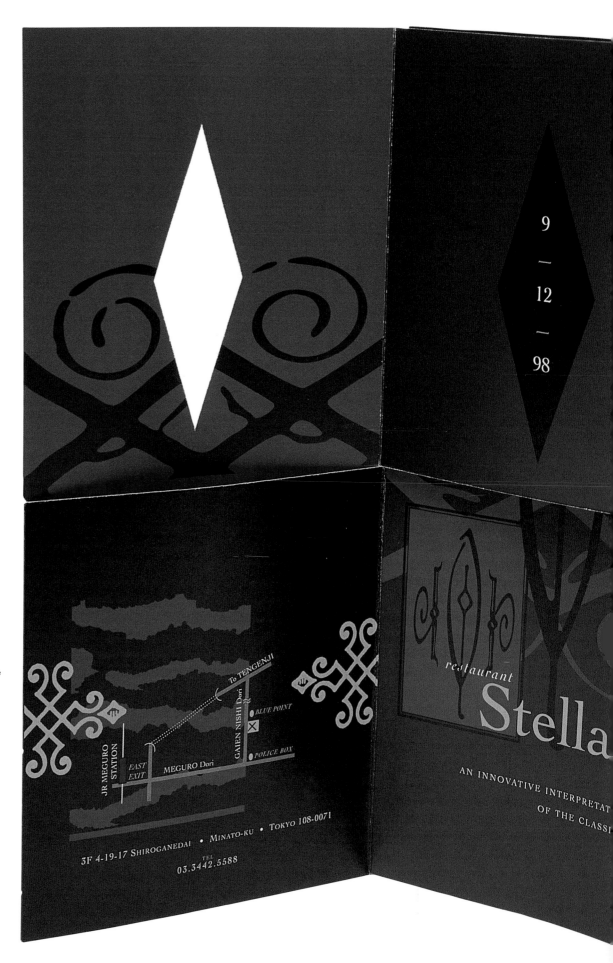

design firm
Vrontikis Design Office

designers
Tammy Kim,
Petrula Vrontikis

creative direction
Petrula Vrontikis

client
Stellato Restaurant

material
cardstock

Stellato Opening Invitation
© Global-dining, Inc.

"The client usually doesn't have a picture of the finished piece in mind, but a concept," says Petrula Vrontikis, describing her surprisingly straightforward approach to tactile design. "So I listen to their most descriptive words about the project, then I try to re-create that in tactile form. When they see the finished piece, and you've gotten it exactly right, you get an 'Aha!'"

One of the biggest "aha's" Vrontikis ever garnered was for an invitation she designed for the opening of the Tokyo restaurant Stellato. "This client and I had done twenty-six restaurants together worldwide, but for Stellato's opening he kept saying, 'This is going to be the most incredible opening, the most incredible opening,' so I decided to make an invitation that would have the most incredible opening, too."

Her decision inspired an invitation that, incredibly enough, never ceases opening. An eight-sided Möbius strip, this wonderful, tactile graphic engages the mind by way of the hand, subverting the ordinarily linear experience of reading while causing the user to continually reconfigure the information in a playful investigation.

Equally important, though, the Stellato invitation illustrates the position of tactile graphics in the design culture *zeitgeist*. "Tactile graphics are becoming more and more important," says Vrontikis, "Because a whole generation of people are now used to seeing things on the screen, and most designs are created that way." A potential drawback of digital design is that it can separate the designer from hand-assembly and, in the process, discourage experiments that reach beyond the two-dimensional surface. When her students at Art Center College of Design see her tactile work, Vrontikis says, "They go wild because they're not used to it. In the same way, tactile graphics can be more effective in the market because it's such a rare thing."

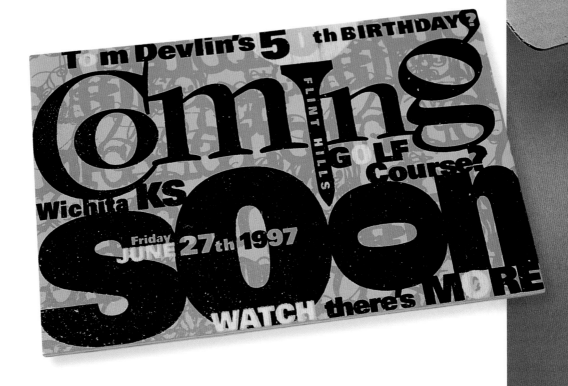

Fiftieth Birthday Party Teaser and Invitation

Dotzero Design was designing signage and other materials for a 60 million-dollar golf course way out in the Flint Hills of Kansas when they were asked to create an invitation for the owner's surprise birthday party. Considering the grandeur of the facility (and that the Beach Boys had been hired to play the bash), the Dotzero designers needed a hole in one.

Drawing on the rustic feel of the hunting lodge–style clubhouse, Dotzero first designed a teaser: a wooden post-card to be sent to invitees. "We had the type silk-screened on rather than printed, to give it a more hand-finished look," Jon Wippich explains. Soon thereafter, invitees received a silk-screened cardboard box containing the actual invitation. Nestled in a cushion of dried grass was a book of 1/16-inch-thick (1.5 mm) color pages, through the center of which a perfect hole had been drilled. A golf ball—imprinted with the course logo—rested in the hole. "Each page of the invitation has photos that progress through [the guest of honor's] life, and we used the hole as the central design element on each page," says Wippich, adding, "We couldn't print on the thick pages so we printed on paper, then laminated [the paper] onto the page."

Although the invitation is lavish, Dotzero's restrained wit and the friendly, tactile nature of the entire package keeps the attention focused on the joy and warmth of the event.

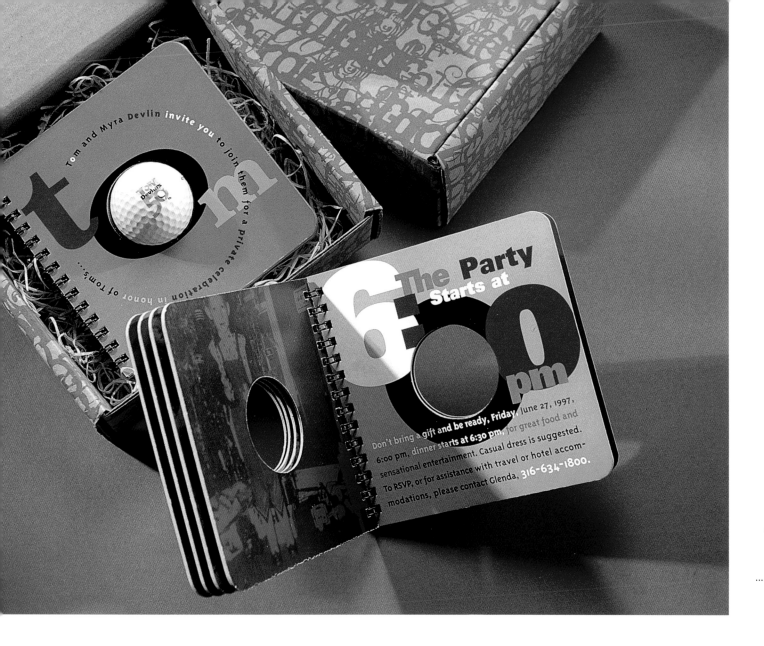

Tom and Myra Devlin invite you to join them for a private celebration in honor of Tom's...

The Party Starts at 6:00 pm

Don't bring a gift and be ready, Friday, June 27, 1997, 6:00 pm, dinner starts at 6:30 pm, for great food and sensational entertainment. Casual dress is suggested. To RSVP, or for assistance with travel or hotel accommodations, please contact Glenda, 316-634-1800.

design firm
Dotzero Design

designer
Karen Wippach,
Jon Wippich

client
private client

materials
wood, laminated heavy
board, raffia, golf ball

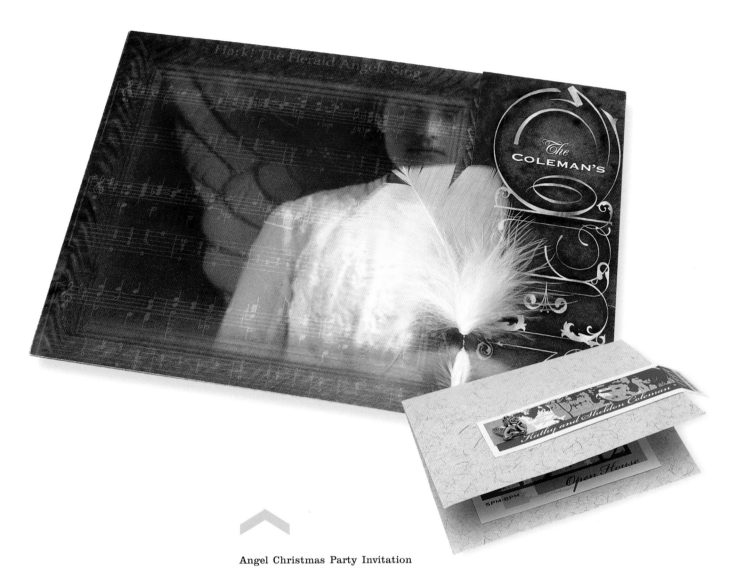

Angel Christmas Party Invitation

Karen and Jon Wippich had been working for a family-owned company for a while when they were asked to design an invitation for the family's annual Christmas party. The client's only request was that an angel somehow be part of the design.

"My wife [and design partner] Karen and I collect old photos from auctions, and we scanned one of those and got wings from a stock CD. We scanned in sheet music for the background," says Jon Wippich. "We were looking for a way to keep the card closed, and we found this bag of feathers at a hobby shop." The feather's quill is inserted through the little notch to keep the card closed. "Having an extra element, like the angel feather on the first card set the tactile theme for all the cards we did over the years."

In keeping with the spirit of giving, one of the angel cards was itself a gift. "We wanted to make an invitation that you could also use as a frame for a photo of your own, once the party was over."

Though these holiday graphics are gentle and mild, the inclusion of a tactile element in each lends a zippiness that points to the humor and geniality of the season.

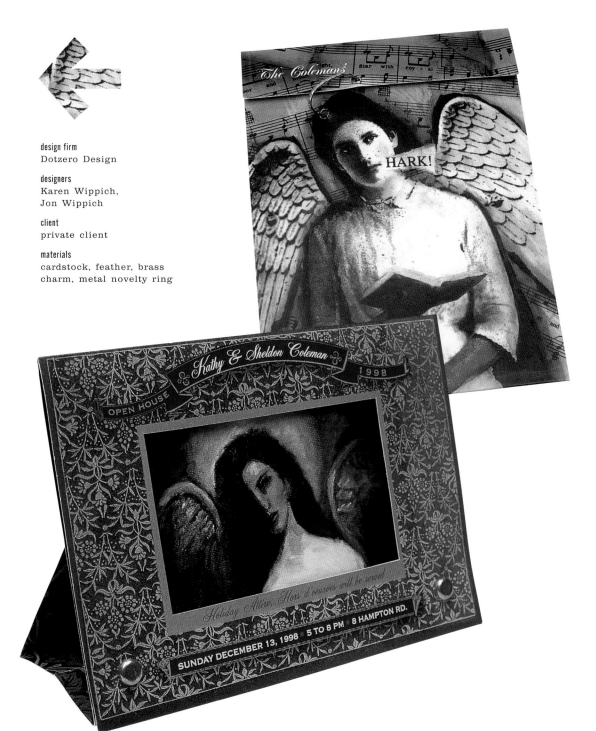

design firm
Dotzero Design

designers
Karen Wippich,
Jon Wippich

client
private client

materials
cardstock, feather, brass
charm, metal novelty ring

Eileen Boxer's invitations for New York's Ubu Gallery are legendary. Boxer gives her own concepts a back seat to the featured artists' whenever possible. "In cases when the artist is living, I insist upon working with them to some degree. I'm not interested in being the artist for these pieces, but in being the graphic designer," she says. Although their visual appeal is obvious, Boxer's designs also have an undeniable tactile power in the hand.

American Institute of Graphic Arts awards notwithstanding, if the real commercial design trophy is audience impact, then Boxer's Ubu invites have made the hall of fame.

design firm
Boxer Design

designer
Eileen Boxer

client
Ubu Gallery

materials
paper, box

Sol LeWitt Opening Invitation

The artist's distance from the piece's final crafting is a critical element in the work of American conceptual artist Sol LeWitt. Starting in the late 1960s, LeWitt shattered the near-universal assumption that a fine artist must necessarily be a craftsperson. Although LeWitt's pieces were inspired and meticulously planned, he didn't execute the work himself. Instead, he armed his assistants with instructions and sent them out to create his pieces.

To begin the design process for Ubu's LeWitt show, Boxer spoke with the conceptualist. LeWitt described what he wanted for the invitation, and this singular, tactile design evolved out of that conversation. "The paper is off the shelf at Staples, a rubber stamp was made for the text, and the mailing house crumpled it. It ended up having such an object quality, and the effect is so simple that it was substantial," Boxer says.

Consider this: Since LeWitt's work is by definition created by others, and since he expressed his wishes for the invitation to Boxer, in a sense each recipient of the invitation received an original work of art!

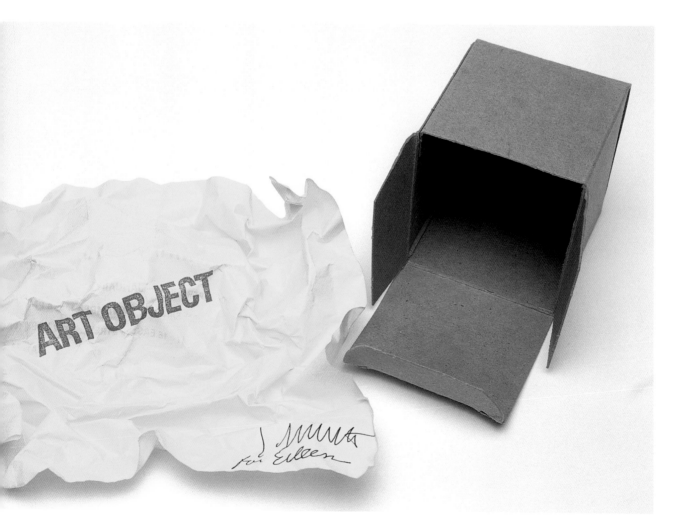

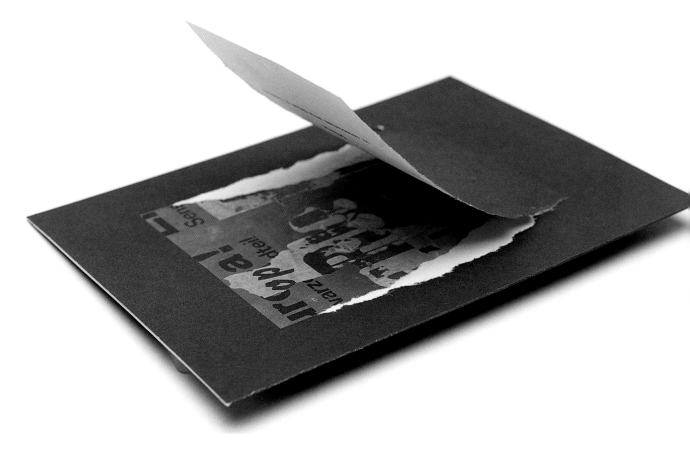

Villegle' Opening Invitation

design firm
Boxer Design

designer
Eileen Boxer

client
Ubu Gallery

material
laminated cardstock

Jaques Villegle' created his art from old posters and other material that the artist found pasted layer upon layer to the walls of the Paris Metro. Villegle' tore the material down, cropped it carefully, then framed it for display.

"I wanted to involve the recipient with this idea of ripped paper," says Boxer. "The printer was so thrilled to work on this, and it was quite simple to do, just a solid black card with four-color on the other side, and it folded, and then the little die cut was put in to [guide] the rip. I wanted it to rip as though it were framed by the black."

Boxer adds, "I like things best where the message is simple and direct and visceral. It gets you involved in what the artist is doing, you're participating in it, receiving the messages that come from ripping paper."

In keeping with the Metro theme, the concept for this piece came to Boxer on the subway, in what she describes as "the Creative Moment, when an idea seems to fall from the sky."

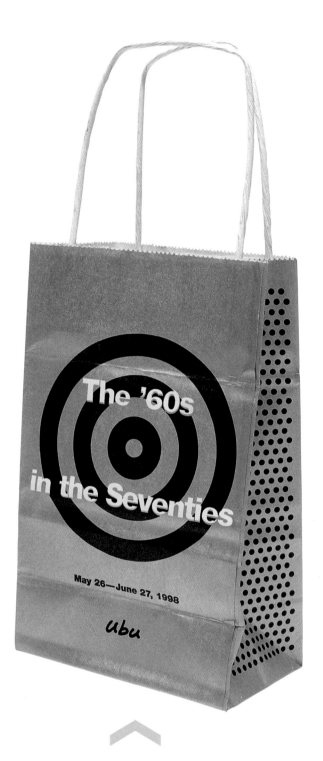

design firm
Boxer Design

designer
Eileen Boxer

client
Ubu Gallery

material
paper shopping bag

The '60s in the Seventies Opening Invitation

For this themed show, Boxer discovered an unlikely
surface for invitations: shopping bags. "Shopping bags
were a big thing, a big means of expression in the '60s,"
she says. Boxer found this interesting version, ordered
the smallest size she could get, then had them printed
in Texas and assembled in Mexico. Every surface of the
bag is printed. "We could have just done a foil stamp on
a plain bag, but doing that wasn't any cheaper."

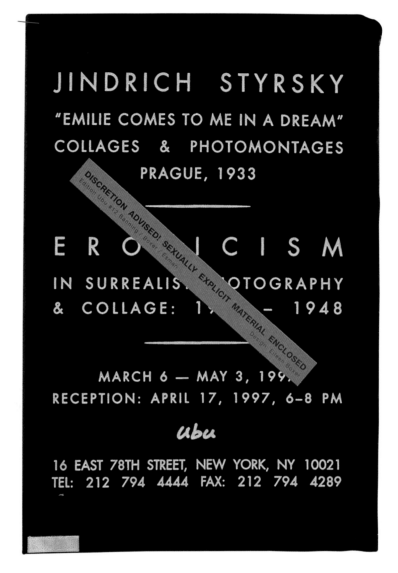

JINDRICH STYRSKY

"EMILIE COMES TO ME IN A DREAM"
COLLAGES & PHOTOMONTAGES
PRAGUE, 1933

E R O T I C I S M

IN SURREALIST PHOTOGRAPHY
& COLLAGE: 1 — 1948

MARCH 6 — MAY 3, 199.
RECEPTION: APRIL 17, 1997, 6–8 PM

ubu

16 EAST 78TH STREET, NEW YORK, NY 10021
TEL: 212 794 4444 FAX: 212 794 4289

DISCRETION ADVISED! SEXUALLY EXPLICIT MATERIAL ENCLOSED
Edition Ubu #12 Banning / Boxer, Espen
Design, Eileen Boxer

design firm
Boxer Design

designer
Eileen Boxer

client
Ubu Gallery

materials
cardstock, plastic sleeve

Eroticism Opening Invitation

"In this country, you can buy pornography, you just can't mail it," Boxer says, describing a concern that guided the invitation design for this show of sexually explicit collages from the 1930s. "Also, children can open the mail or see it, and we wanted to be sensitive to that."

The muscle behind this tactile graphic is in what you can't see. As Boxer describes it, "You hold it, and your fingers are almost burning to know what's inside." What's inside the jet-black plastic wrapper is a standard postcard printed with imagery from the show.

Boxer's tried-and-true mailing house had a heat-sealing machine that sealed the little envelopes.

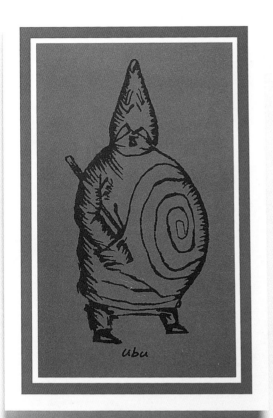

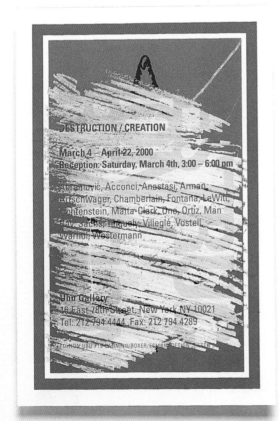

design firm
Boxer Design

designer
Eileen Boxer

client
Ubu Gallery

materials
cardstock, scratch-off
material

Destruction/Creation Show

"Most people on the Ubu mailing list know to expect something, that they'll need to be involved in the invitation in some way," Eileen Boxer says, chuckling. The Ubu gallery invited its fans to the opening of the show called "Destruction/Creation" by sending them this orange card...and a penny. "We thought that would be the clue to figuring out what to do."

Printing on scratch-offs can be a challenge. "The scratch-off material has to be sealed," Boxer explains, "But rather than doing it as a separate coating, we did it as a reverse, with the light part of the image sealed and the dark portion left unsealed. It's really just a two-color job."

As in all her work, Boxer kept the concept paramount here. "The most important thing was to create something that had to be destroyed or tampered with in some way, in order to get to the information," she says, adding, "We got that."

"It's so important to me to get people to think about things, it makes me enjoy doing this work. If you get people to ask questions, if you leave them with something in their minds, you've done something. It's like a good movie; Does it bring something into your life?": EILEEN BOXER

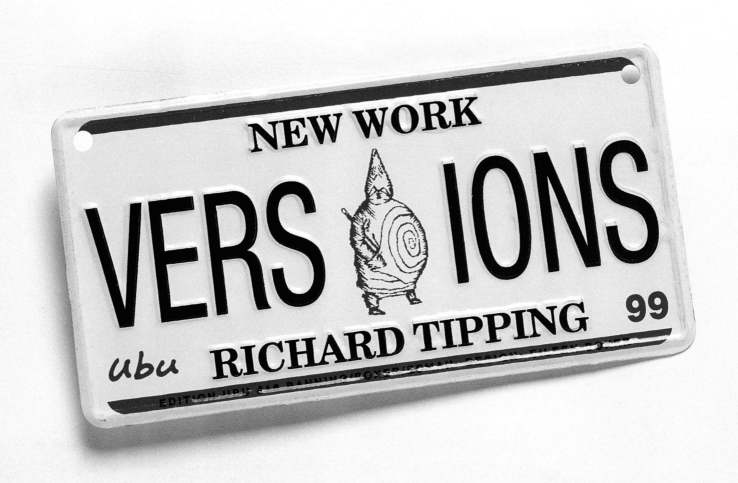

Richard Tipping Opening Invitation

Found objects, metal signage, and the influence of surrealism all turn up in the work of artist Richard Tipping. Boxer got the idea for this invitation from one of Tipping's found-object pieces—a souvenir license plate with the name "Art" preprinted on it. Tipping bought the little plate in a shop, signed it, and added it to his oeuvre. When Boxer saw it, she suggested using custom-made souvenir plates for the show's invitations.

"I have this great supplier, Electromark, and they did the metal stamping. The owner, Blair Brewster, is a great fan of conceptual art, and the two of them [Brewster and Tipping] have gone on to collaborate on other things.

design firm
Boxer Design

designer
Eileen Boxer

client
Richard Tipping

material
stamped metal

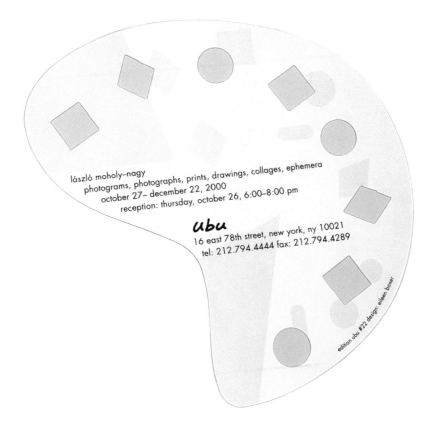

lászló moholy–nagy
photograms, photographs, prints, drawings, collages, ephemera
october 27– december 22, 2000
reception: thursday, october 26, 6:00–8:00 pm

ubu
16 east 78th street, new york, ny 10021
tel: 212.794.4444 fax: 212.794.4289

edition ubu #22 design: eileen boxer

Moholy-Nagy Opening Invitation

Although Moholy-Nagy made very
few actual photographs in his career, he
nonetheless is a major figure in the history
of modern photography. Much of his extant
work is in the form of "photograms":
shapes both familiar and abstract burned
and dodged into photographic paper with
a variety of instruments.

When this Ubu invitation is removed
from its envelope, it filters ambient light,
creating something akin to a photogram on
whatever surface is beneath. "I like the way
this one gets you involved in the process,"
Boxer says.

design firm
Boxer Design

designer
Eileen Boxer

client
Ubu Gallery

material
transparent plastic

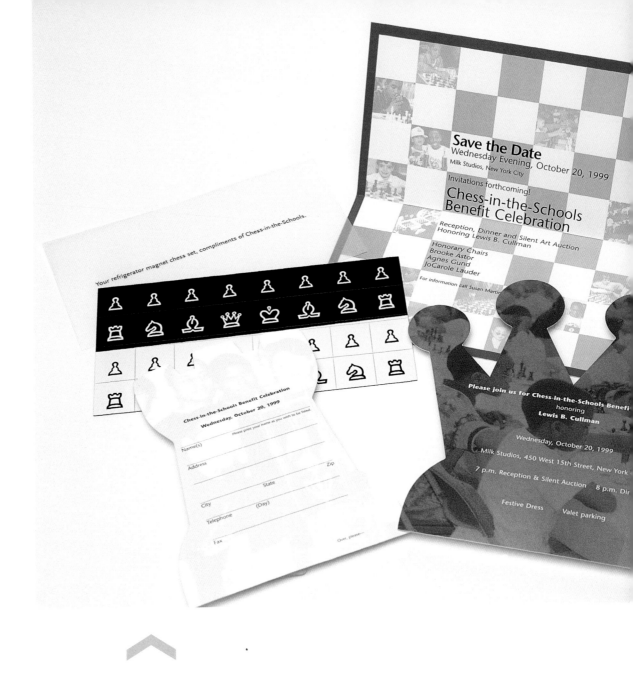

Your refrigerator magnet chess set, compliments of Chess-in-the-Schools.

Save the Date
Wednesday Evening, October 20, 1999
Milk Studios, New York City

Invitations forthcoming!
**Chess-in-the-Schools
Benefit Celebration**

Reception, Dinner and Silent Art Auction
Honoring Lewis B. Cullman

Honorary Chairs
Brooke Astor
Agnes Gund
JoCarole Lauder

For information call Susan Martin

Chess-in-the-Schools Benefit Celebration
Wednesday, October 20, 1999

Please print your name as you wish to be listed

Name(s)

Address Zip

State

City (Day)

Telephone

Fax Over, please...

Please join us for Chess-in-the-Schools Benefit
honoring
Lewis B. Cullman

Wednesday, October 20, 1999
Milk Studios, 450 West 15th Street, New York
7 p.m. Reception & Silent Auction 8 p.m. Dinner
Festive Dress Valet parking

design firm
Boxer Design

designer
Eileen Boxer

client
Chess-in-the-Schools

materials
paper, perforated
magnetic material

Chess-in-the-Schools Teaser, Invitation, Program, and R.S.V.P.

Teachers and researchers alike agree that the game of chess builds cognitive ability, life skills, and enthusiasm for learning in school-age children. Chess-in-the-Schools is a nonprofit that puts chess to work helping kids in New York City's schools.

Designer Eileen Boxer donated her talents to the program's first major fundraising event, creating these charming and effective tactile designs. "I wanted to do something about children but also about chess," she says. "I thought, 'Why don't we send everyone a chess set?'"

One of Boxer's vendors not only manufactured the magnetic chess sets to her design but donated them to boot. "It's a pretty simple design based on a font that I altered in Illustrator. It's one-color printing and then you perf it," she says.

The magnetic chess sets were mailed first as a save-the-date teaser, and the king invitation arrived later, along with the rook RSVP. When guests arrived at the actual event, the knight programs were standing on each dinner plate on every table. "Paper sends a subtle message about the quality of the whole event. If you use paper that doesn't say anything, you've sort of blown it. This is your chance to really convey something," Boxer adds.

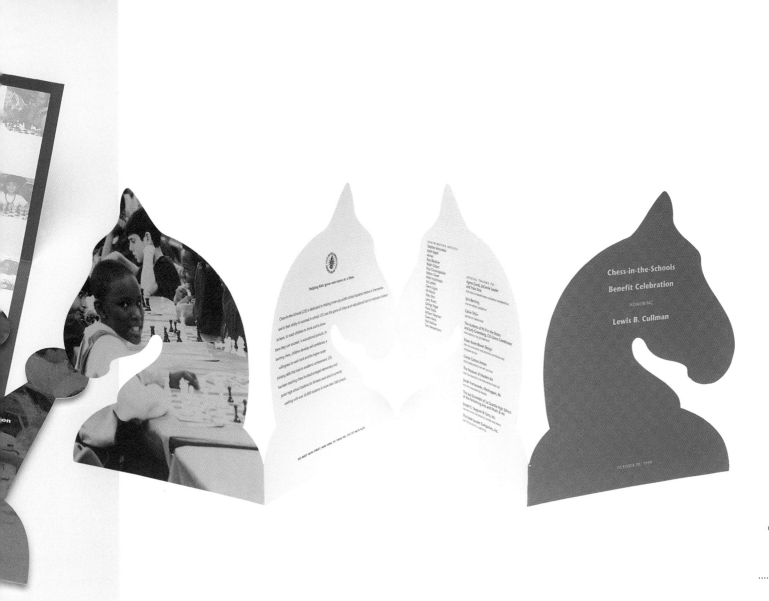

"It's a subtle thing that you're doing, and it's not appropriate to every project to do a concept piece. If you do it just to do it, people will ask the wrong questions. You want to be smart, not cutesy.": EILEEN BOXER

"The challenge is to be as smart as possible in a commercial medium. Inspiration comes from the parameters that you set up around a problem, but there's always a little bit of mystery around the creative process. People ask, 'How did you think of that?' and I don't honestly know. After pushing hard, the final idea comes in almost a dream state.": EILEEN BOXER

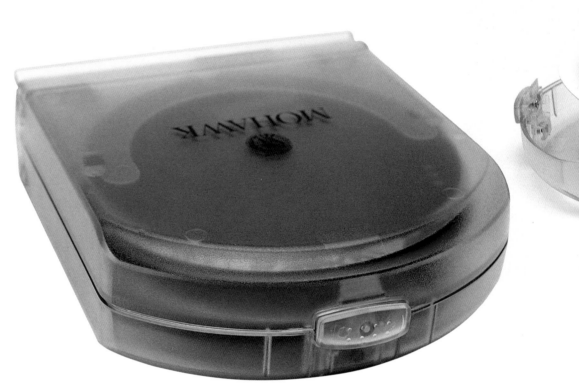

design firm
Chen Design Associates

designers
Joshua Chen, Kathryn
Hoffman, Leon Yu,
Gary Blum

illustrators
Gary E. Blum, Elizabeth
Baldwin

photography
Joshua Chen, Leon Yu

client
Mohawk Paper Mills

materials
plastic CD case, paper

Mohawk Mills Party Favor CD Case

Oh, the horrors of business party-going. It's neither completely business nor completely fun, so many folks spend the evening either avoiding responsibility or each other. However, having something really interesting to talk about can be just the thing to break the ice.

Take this very functional and funky favor, presented to attendees of Mohawk Paper Mill's West Coast gala.

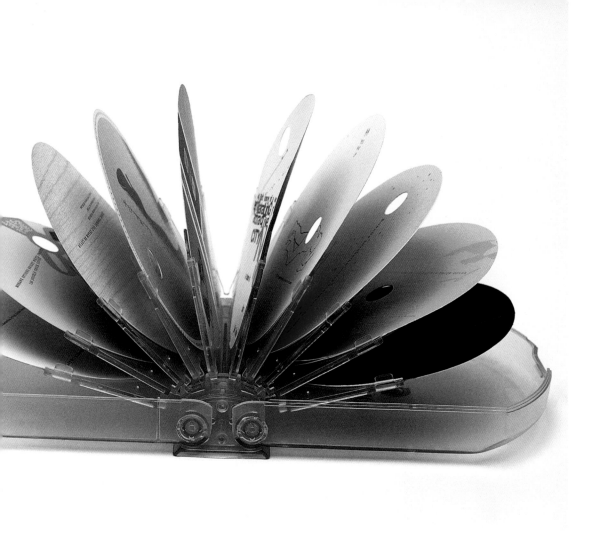

"The event was held at the Great American Music Hall in San Francisco," says designer Joshua Chen. "So Mohawk suggested giving away CD holders with paper CDs that would show off their papers. We were told we could design whatever we wanted, but the challenge was completing the project in only three and a half weeks."

As a thank you to Mohawk Paper, five area printers and two die-cut houses volunteered to help on this pro bono job, which featured wacky text researched and written by Chen's team to highlight the music scene in San Francisco. For example, attendees who pulled out the Mohawk Satin Blue White sample enjoyed reading that The Who kicked off their '73 tour at the Cow Palace. Next to a less-than-glamorous line drawing of a vertically challenged rocker, the text reads, "After drummer Keith Moon passes out on stage twice, a frustrated Pete Townsend calls out to the audience in search of anyone to take his place."

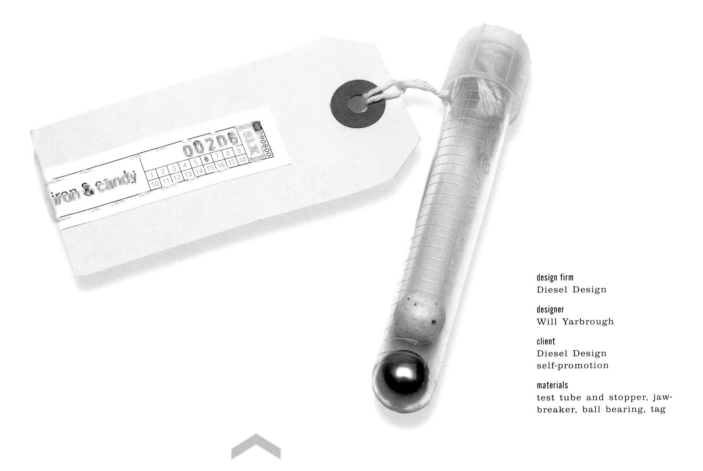

design firm
Diesel Design

designer
Will Yarbrough

client
Diesel Design
self-promotion

materials
test tube and stopper, jaw-
breaker, ball bearing, tag

Sixth Anniversary Invitation

"When we're doing something for ourselves we can really blow it out design-wise, just so there's a solid concept behind it," says Diesel designer Shane Kendrick. For this invitation to Diesel's sixth anniversary party, the admittedly materials-oriented shop let concept take the lead.

"Candy and iron are the traditional gifts for the sixth anniversary," Kendrick explains. "The designers started researching things that would contain the little jawbreaker and the ball bearing perfectly, and they found this great test tube in a scientific supply catalog." The tag dangling from the tube invites recipients to RSVP on-line, which served the double function of driving eyeballs to Diesel's Web site.

design firm
Diesel Design

client
Diesel Design
self-promotion

material
paper

Fifth Anniversary Invitation

"If there's one thing that's a constant theme here, it's making work that's fun, cost-effective, and high-impact," declares Diesel Design founder Jeffrey Harkness. This simple invitation to the company's fifth anniversary party not only filled the bill, but did it with a tactile flourish.

"It's an invoice from a mechanic shop," says Harkness, "Just a one-color print job. But people loved the details like the greasy fingerprints and 'Please *play* this amount.' Also, they loved that you could tear off the second sheet and fax it to us to RSVP."

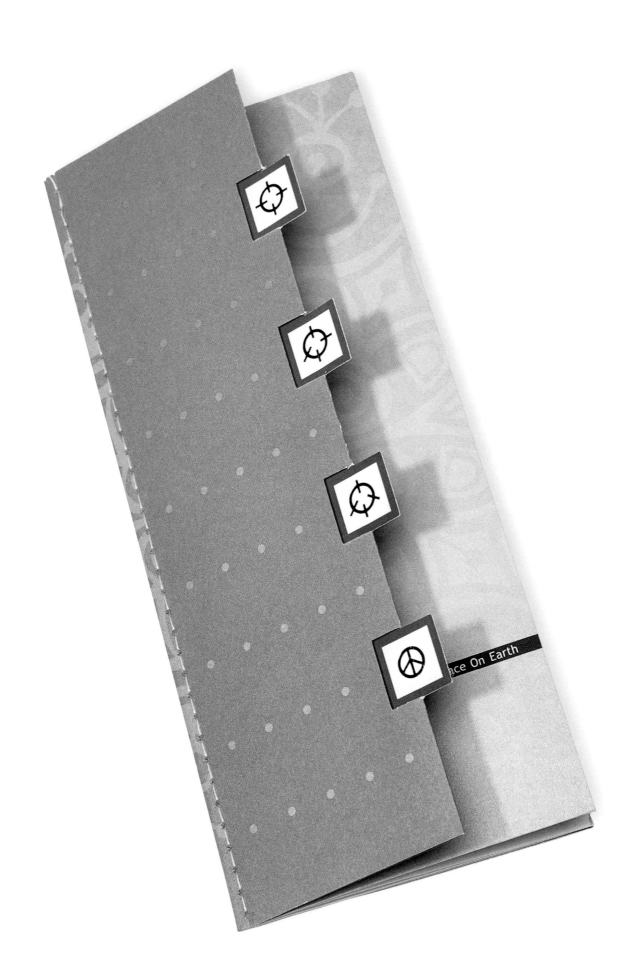

CJ Graphics Christmas Party Invitation

CJ Graphics is a hip Toronto print shop that has positioned itself to attract designers rather than deal directly with advertisers. The invitation for CJ's legendary annual Christmas party is designed by a different Toronto design firm each year, and the commission is coveted.

When Riordon Design Group was asked to create the invitation, they decided to skew toward the tactile as a way of showcasing what CJ Graphics can do. "We wanted it to be a keeper, more of an accessory rather than something you'd throw away," says Ric Riordon. "We chose [card]stocks that showcased a variety of textures and finishes. CJ Graphics is associated with a bookbinder, so we had the piece sewn together. In the mind of the user, the handwork says that you've taken care, that you've given the piece your attention."

design firm
The Riordon Design
Group, Inc.

designer
Shirley Riordon

client
CJ Graphics

materials
various papers,
stiched binding

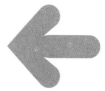

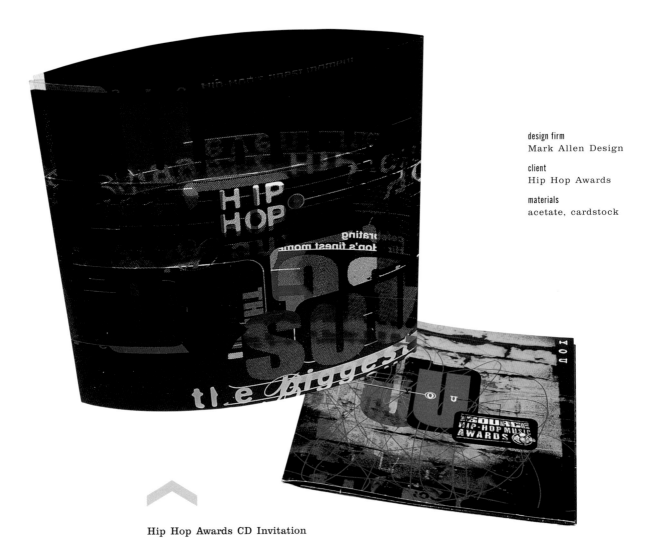

design firm
Mark Allen Design

client
Hip Hop Awards

materials
acetate, cardstock

Hip Hop Awards CD Invitation

There's a particular thrill to tactile designs that require breaking, ripping, and tearing. For this VIP invitation to the Hip Hop Awards, Mark Allen says, "I wanted to use the cover to play up the 'street' aspects of the music, the stuff in urban culture that you actually see and touch." Allen's solution was an invitation that reads like layer upon layer of graffiti, wrapped in an acetate sleeve that has to be broken to access the information—and free CD—inside.

design firm
Wen Oliveri

art direction/design
Jamie Oliveri,
Cinthia Wen

client
Patrick Robinson

materials
watercolor paper,
fabric

Fashion Show Invitation

Wen Oliveri recognized that Patrick Robinson was a unique fashion designer, a man driven by a personal mission of simplicity and integrity. For this invitation, Oliveri says, "We worked really closely with Patrick. He has a strong sense of material and the tactile, and this particular collection had a lot of hand treatments in the clothes.

"We wanted to carry that over into the invitation. It was cost-effective, but it also had less of a mass-produced feeling."

The watercolor paper was torn by hand, the message was stamped, then a sewing machine was used to stitch on the fabric swatch. "In fashion, it's easy to get too slick," Oliveri says. "We were after something more human."

from PROMOTING WITHIN

Although many design firms rely on word-of-mouth or repeat business for their livelihood, there comes a time when they need to go out and sell their services. Self-promotions are literally a firm's lifeline to new business, and the creative stakes are high. **The biggest challenge for designers comes not from clients, but from themselves, often struggling between self-expression and a tight budget. The most successful examples of self-promotion by graphic designers are conceived in the realization that the artists themselves are their own best promotional material. All of the pieces presented here express the quirky, individual, and extraordinary results of designers who have looked within for guidance.** Take Geoffrey Lorenzen of Portland's Omatic Design, for example. For days he struggled to come up with the perfect holiday gift for clients, then at the last moment threw out all his clever ideas and invested instead in his own sense of humor: He had his logo embroidered on jockey shorts. **Likewise, Sara Schneider decided to focus on her own personality with the emotionally vibrant self-promotion entitled Shyness. This portfolio is a revelation of the designer's psyche that recipients report is not only engaging but inspiring. The piece got Schneider in the door for all the important jobs she's had since graduating college.** Whether pulling at the heartstrings or tickling the funny bone, each piece in this chapter reflects and expresses the inner world of its creator.

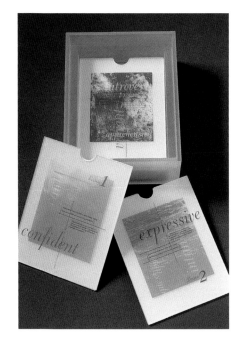

design firm
MATTER

designers
Jason C. Otero,
Rick Griffith

client
MATTER self-promotion

materials
Paint can, traffic cone,
particle mask, brick,
plumbing tee, brick, 3-D
signage lettering, paint
can with latex gloves,
traffic cone

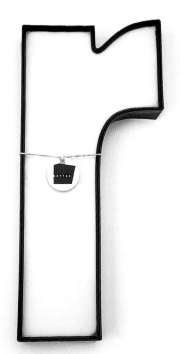

Found Object Self-Promotions

"We solve design problems for a variety of media," says Jason Otero
of the Denver design studio MATTER. MATTER's slogan, "MATTER
surrounds us," reflects the studio's multidisciplinary scope,
which is given form in these found-object self-promotion pieces.

"The materials we use have to connect thematically to the piece
we're working on," says Otero.

design firm
Dotzero Design

designers
Karen Wippich,
Jon Wippich

client
Dotzero Design
self-promotion

materials
Formica, adhesive vinyl,
brass, rubber

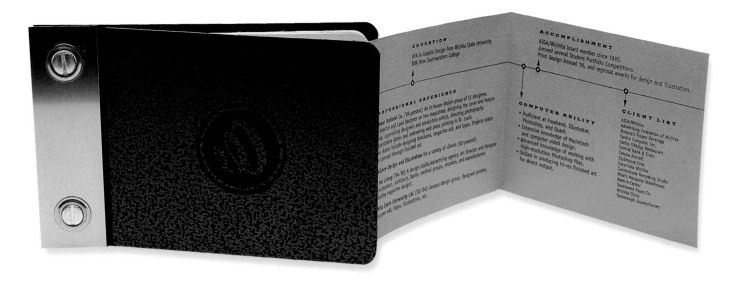

Formica Self-Promotion

Self-promotions often have a double burden: They must represent the creative spirit of the sender, and they are often produced with little or no budget. Fortunately, tactile graphics is the perfect medium to express high artistry on a slender pocketbook.

The cover of one of designer Jon Wippich's most successful self-promo pieces gets its expensive, finished look from Formica—a material usually associated with frugality. Out of its usual counter-top context, though, the Formica feels unexpectedly consequential. Wippich reports that, "When I leave the book behind for clients, they say, 'You mean I get to keep this?'"

Wippich decided on the rubber binding after realizing that Formica was too brittle to bind directly, and paper too fragile. "I remembered this company that sells rubber belting, and it was perfect, and they also gave me a special contact adhesive," he says. "Then I found the brass plaque at a trophy store and had them drill holes in it. A leather store crimped the grommets." A silk-screening vendor cut the logo out of vinyl, and Wippich burnished it on by hand.

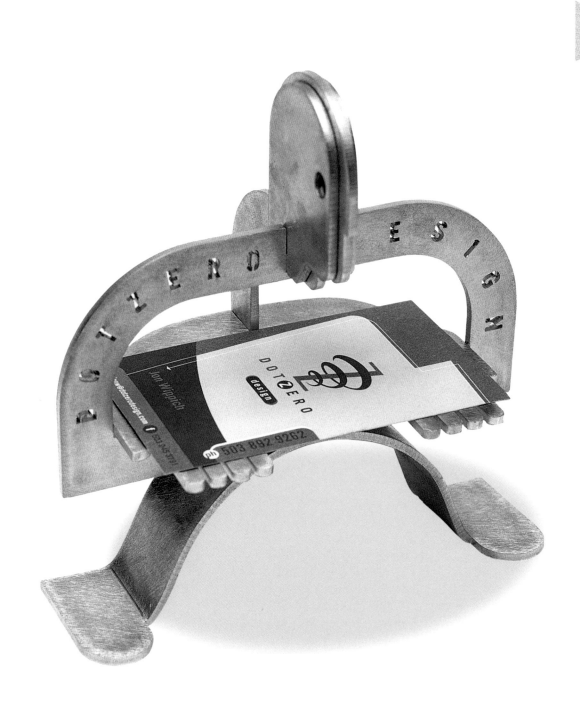

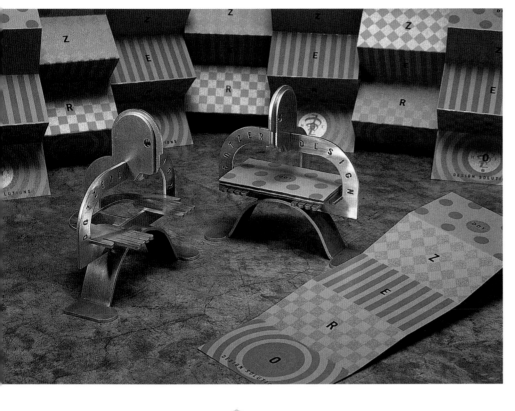

design firm
Dotzero Design

designers
Karen Wippich,
Jon Wippich

client
Dotzero Design
self-promotion

material
aluminum

Aluminum Man Card Holder

It is an ongoing challenge for designers to create a
self-promotion that will stay in clients' hands, rather than
in the circular file. This business card holder self-promo
for Dotzero uses a witty, tactile design to solve that problem.

Jon Wippich approached a metal-cutting shop with a
cardboard mockup of his burly little roustabout. "At first
I wanted it in steel, but I also wanted the legs bowed, and
the metal cutters showed me that it would be much easier
to bend aluminum." Wippich and the metal cutters refined
successive drafts until the design was not only delightful
to look at, but structurally integral: The limbs of the
aluminum laborer are designed to hold together without
soldering.

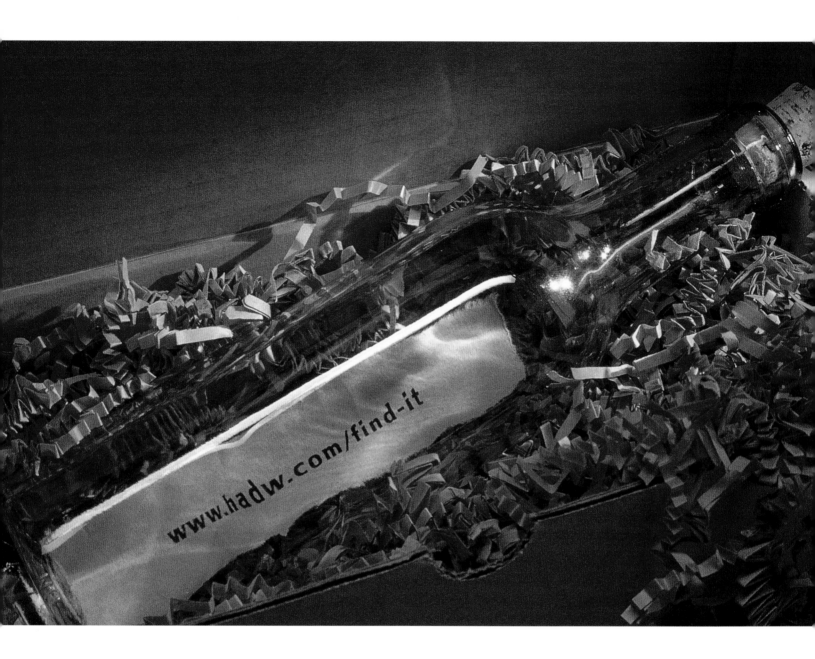

www.hadw.com/find-it

design firm
Hornall Anderson Design
Works, Inc.

client
Hornall Anderson Design
Works, Inc. self-promotion

materials
glass bottle, paper,
metal can, can opener

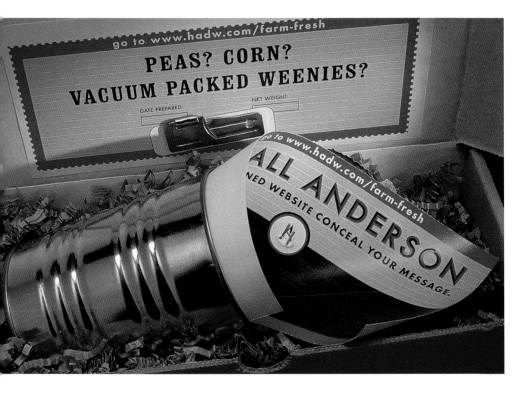

Message-in-a-Bottle and Paint Can Self-Promotion

"People were given hands for a reason," says Chris Sallquist, partner in Hornall Anderson Design Works, Inc. "We like the sensation of picking things up. I still print articles out from my computer so I can hold the pieces of paper in my hand; it's just easier for me to comprehend that way. And that's why three-dimensional design enriches our experience. You just have to get more involved with it."

Running with this theory, Sallquist decided to create a promotional campaign for the launch of Hornall Anderson's on-line creative services division. By sending a message in a bottle and, later, a message inside a paint can (accompanied by a can opener), he literally forced users to pick up his message and play with it. Both pieces were packaged without a Hornall Anderson label, yet both contained messages that drove the user to a Hornall Anderson URL advertisement displaying the company's ability to build enticing Web sites. Sallquist explains that the inexpensive stunt garnered a substantial amount of new business, but did require a few overtime evenings, hand-stuffing bottles and cans.

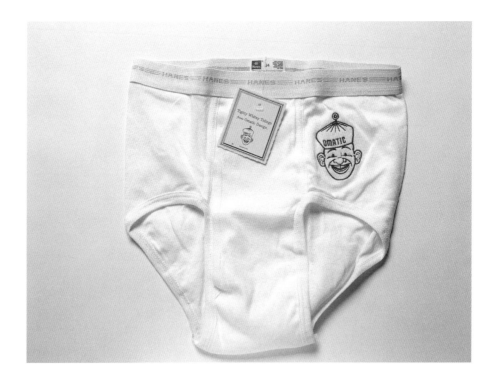

design firm
Omatic Design

designer
Geoffrey Lorenzen

client
Omatic Design
self-promotion

material
embroidery on briefs

Tighty Whitey Tidings

"Aside from a lump of coal, underwear is the ultimate lousy Christmas gift," says Geoffrey Lorenzen of Portland's Omatic Design. Not really a shopper himself, Lorenzen decided it was much easier to create something truly tacky and get a laugh than spend precious hours—and dollars—coming up with the perfect holiday self-promotion.

His ability to forego the art and just have fun led him to the idea of embroidering one of his deliciously retro logos onto Tighty Whitey briefs for men. Lorenzen supplied his embroidery vendor with vector art from Adobe Illustrator to complete this—pardon the pun—short run. He explains that although it may not have won him any business directly, it did get a lot of laughs. "When I went in to one agency we contract for, one of the guys was wearing them over his jeans."

Logo Book

For Dotzero's logo portfolio, Jon Wippich wanted to create a piece with a substantial feel but without the cost of offset printing. "I found the material for the cover at an electronic salvage. I didn't even know what it was until a photographer friend told me it's the stuff they use for circuit boards. I just liked it because when you hold it up to the light it has this great amber look, and a kind of cloth pattern, and the surface is real slick." The contents were laser printed and comb bound. Finally, Wippich says, "I borrowed a corner-rounder and trimmed the covers to give it a more finished look."

design firm
Dotzero Design

designers
Karen Wippich,
Jon Wippich

client
Dotzero Design
self-promotion

materials
phrenolic circuit board
material, board cover,
plastic comb binding

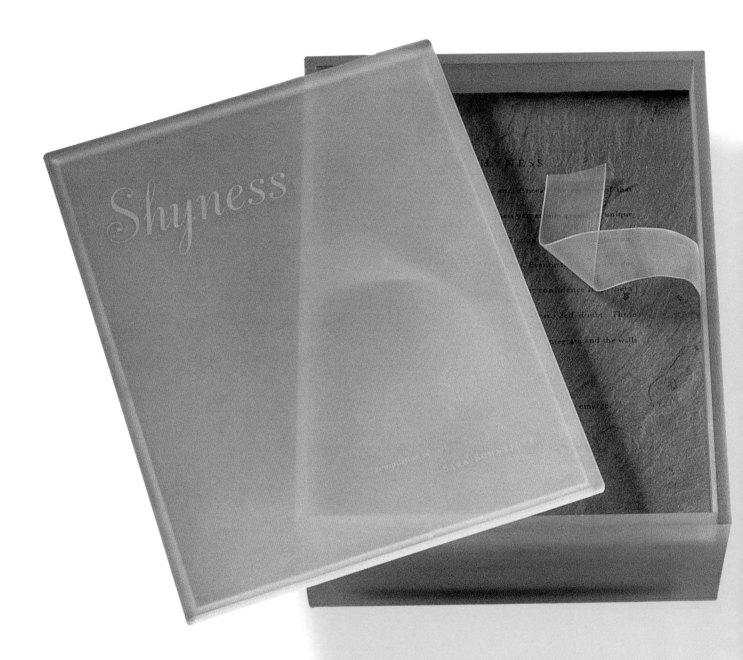

"A tactile piece involves the viewer, it makes them participate in it, and gives another level of perception and communication. Also, it's not often possible to achieve texture in massively produced collateral, so when you can do it, it's attention-getting." : SARA SCHNEIDER

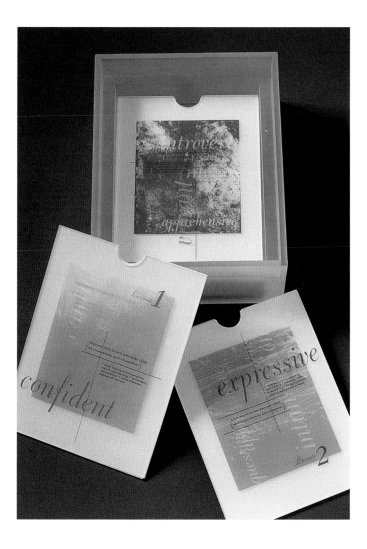

designer
Sara Schneider

client
Sara Schneider
self-promotion

materials
Plexiglas, slate,
stainless steel

Shyness Portfolio

In graphics, a book is necessarily judged by its cover. Unfortunately for young artists just out of school, the message of that standard black vinyl-and-leather portfolio case can be, "Here comes yet another designer."

Sara Schneider wanted a portfolio that would make an unequivocal statement about herself and her work and so created this radical tactile design based on her personal journey from Shy Child to Mature Designer. "In art school I learned that my introspective nature actually developed qualities in me that I might not have otherwise had, qualities that enhance my ability as a designer. I wanted my portfolio to reveal that."

Schneider commissioned a 7.5" x 9.5" x 4" (19 cm x 24 cm x 10 cm) Plexiglas box, had it sandblasted, and the word "Shyness" engraved on the cover. "When a person is shy, you can't see through the exterior, but you can tell there are beautiful things inside," she says.

Removing the lid, the user is stopped by a panel of solid slate on which is engraved some of Schneider's poetic prose about shyness. Beneath the slate panel are six sandblasted Plexi plates: Schneider silk-screened original photos of walls onto the plates by hand, and each features one word expressing a characteristic hidden within the shy person: "Confident," "Vibrant," "Expressive," etc. Between each of these plates, Schneider placed 4"x 5" (10 cm x 13 cm) mounted transparencies of her work.

A stainless steel block at the bottom of the box, surrounded by crumbled slate, is Schneider's representation of a strong personal core rising out of pulverized obstacles.

"Getting the inks to adhere to the sandblasted surface was challenging," Schneider adds. **"Also, I had to grind the slate into powder by hand, in a mortar and pestle."**

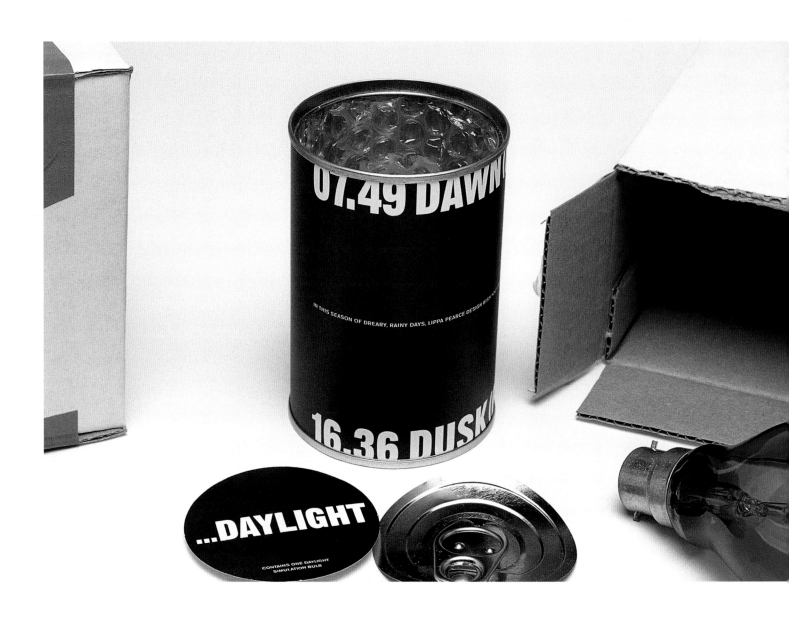

Lightbulb-New Year's Greeting Card

When you pop open this sealed can, the first thing you see is an insert reading, "...DAYLIGHT." And daylight there is, in the form of a daylight simulation lightbulb.

"Our studio is literally on a river," explains designer Harry Pearce. "One day, Domenic and I were walking to get lunch at a little café across the bridge. It was such a dull, miserable afternoon that I said, 'Let's send daylight to our customers.'"

In an ode to the playful works of Marcel Duchamp, Pearce and cofounder Domenic Lippa bought one thousand lightbulbs and found a manufacturer to seal them in aluminum cans. "We had to do dozens of experiments to figure out a safe packing system for the bulbs. Once we figured that out, we sent all the contents to a packaging house and they sent us back the sealed-up tins. Since we spent all our budget on that process, we had to apply the labels by hand."

design firm
Lippa Pearce Design Ltd.

designers
Harry Pearce, Jeremy Roots

art direction
Domenic Lippa, Harry Pearce

client
Lippa Pearce Design Ltd. self-promotion

materials
aluminum can, packing material, paper, paper label, day simulation lightbulb

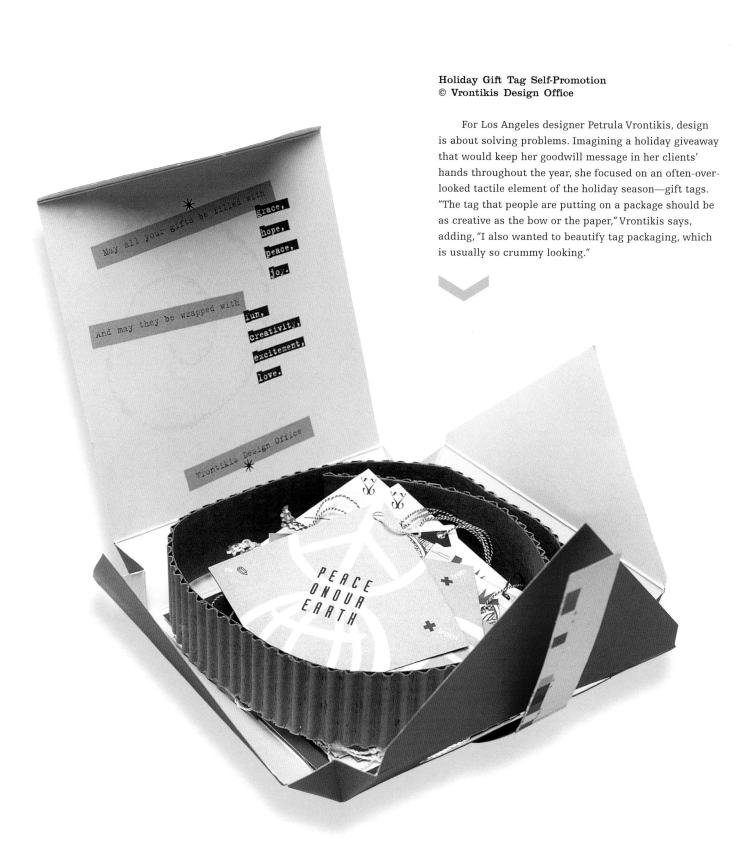

Holiday Gift Tag Self-Promotion
© Vrontikis Design Office

For Los Angeles designer Petrula Vrontikis, design is about solving problems. Imagining a holiday giveaway that would keep her goodwill message in her clients' hands throughout the year, she focused on an often-over-looked tactile element of the holiday season—gift tags. "The tag that people are putting on a package should be as creative as the bow or the paper," Vrontikis says, adding, "I also wanted to beautify tag packaging, which is usually so crummy looking."

There was a second problem to solve. "I wanted to give something that wouldn't get thrown away." Concluding that the most valued gifts are the ones that are truly meaningful to the giver, Vrontikis decided that the gift-tag giveaways should also express her commitment to recycling. "I think it's a designer's responsibility to be as aware of the options as possible, and when we can use recyclable material, it's our responsibility to do so."

All the gift tags that Vrontikis has sent out over the years are printed on some form of recycled material: Money Paper made from recycled currency, Beer Paper made from hops and recycled beer labels, and Golf Paper made from golf-course grass clippings. The process that generated the majority of gift tags, however, epitomizes the designer's role in the responsible use of precious resources: "All during the year, as jobs were

design firm
Vrontikis Design Office

creative direction
Petrula Vrontikis

client
Vrontikis Design Office
self-promotion

materials
cardstock, string,
metal can

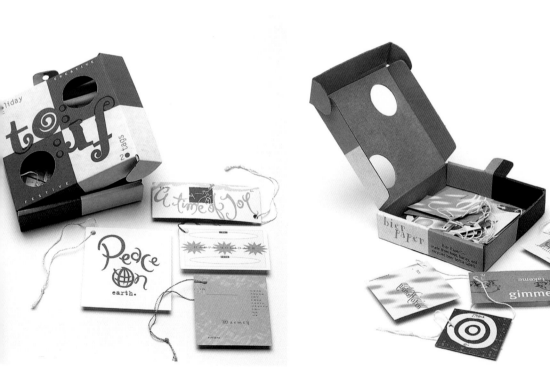

Holiday Gift Tag Self-Promotion [continued]

going to be printed, we would find out if there was extra room on the press sheet," says Vrontikis. "If there was, we would give the printer a file of gift tags that matched the extra room. Then we could just trim the tags off the end of the sheet. We had no control over the kind of paper the tags were printed on, but the printer would usually do it for free, so we could print on paper that would normally be thrown out, and without it costing the clients or us anything."

In November, as the holidays approached, "We would design the packages fast, which we always looked forward to. Everybody in the studio was in on it, even interns, so the tags were always this big creative outburst."

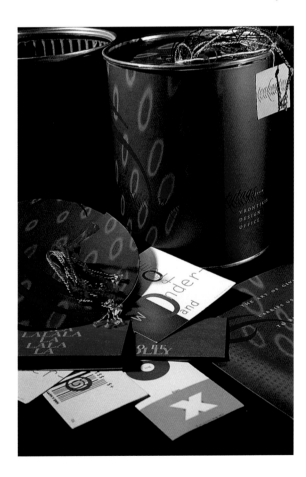

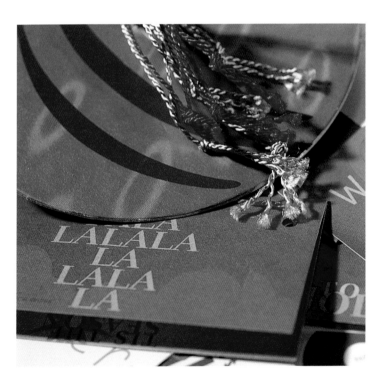

auf – gelesen

picked – up

Schwerter zu Pflugscharen:
Über diese Klinge
Ist keiner gesprungen
Niemandes Haar wurde
gekrümmt:
ein guter
Schnitt
für ein Stück Stahl
das üblicherweise
durch Stoppelfelder pflügt
doch niemals
zum Pflug wird

design firm
Felder Grafikdesign

art direction, design, copy
Peter Felder,
Johannes Rauch

client
Felder Grafikdesign
self-promotion

materials
paper, stitched binding,
postage stamp, leaf, film
negative, feather, razor-
blade, lint

Auf Gelesen (Picked Up)

Picked-Up is a self-promo celebrating the millennium.
With this piece, designer Peter Felder explored "the beauty
of unimportant things, things that are actually packed
with small stories. Self-ironic, laconic, timeless. Things
to touch."

Everyday elements, like a razor blade or a leaf on the
right hand pages, are mirrored by spare, poetic text, evok-
ing the more fanciful meanings of the objects. Pasted onto
the front cover, a simple circle of paper; on the back cover,
the negative space it once inhabited—the eternal suggest-
ed by the mundane.

Felder printed three hundred of these enigmatic self-
promotion pieces and attached the found objects himself.
He and his design partner Johannes Rauch went through
four bottles of Calvin Klein's Eternity, spraying the aptly
named cologne onto a single sheet inside each book.

2000 Calendar

Lest some of the biggest fans of tactile design be overlooked, we should mention the countless vendors who appreciate the offbeat challenges that tactile design presents. For a five hundred–run of this gift calendar fashioned like a swatch book, Diesel Design approached a manufacturer of ductwork. "The rivets are standard, but the metal had to be folded to spec, so we had to work with them pretty closely," says Diesel's Shane Kendrick. "They really enjoyed doing something different for a change, instead of just ducts and more ducts."

design firm
Diesel Design

designer
Will Yarbrough

artists
Michael Lemme, Walter Lopez, Josh Glenn, Luis Dominguez, Alicia Boelou, Jeffrey Harkness, Jacquie Van Keuren, Emily Cohen, Will Yarbrough, Ned Horton, Amy Bainbridge, David Wilson, Cindy Sweeney

client
Diesel Design
self-promotion

materials
cardstock, aluminum

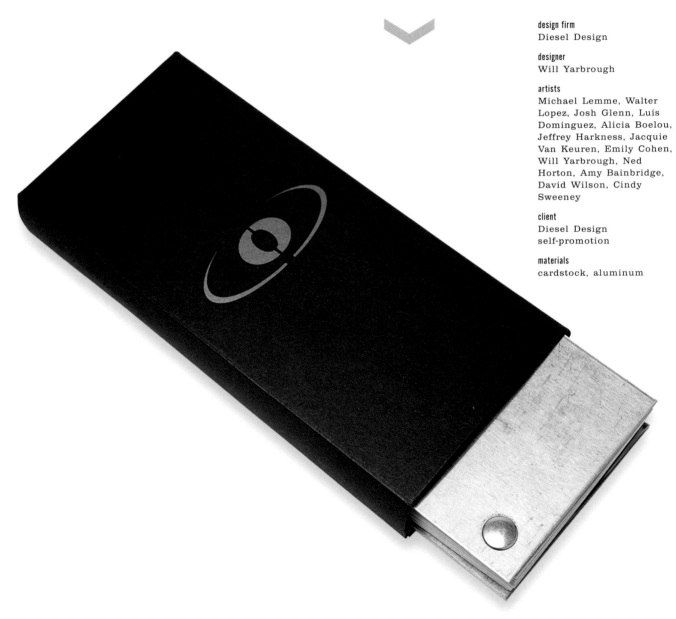

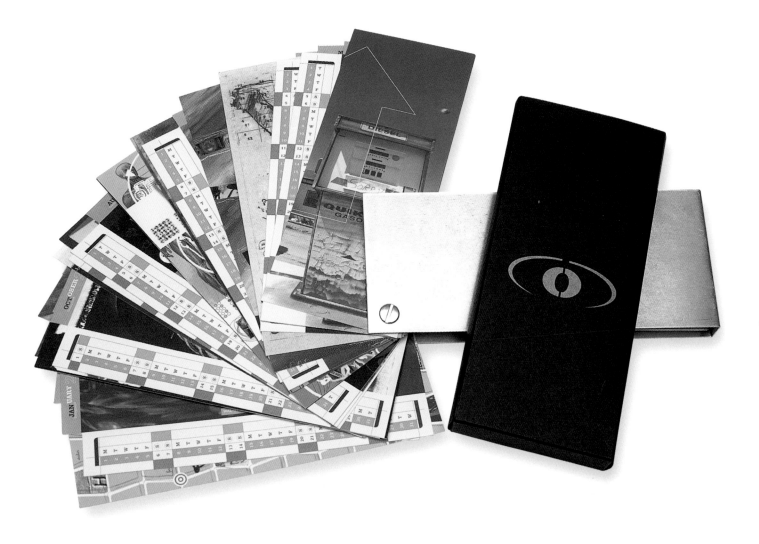

Moving Announcement

"The Fuel to Power Your Ideas", is Diesel Design's motto, and when clients (and potential clients) make the mailing list of the Bay-area firm, they learn to watch the mailbox for a stream of high-octane self-promos.

When Diesel moved shop to a new location, the announcement was printed on this silk-screened shop rag, enclosed in a metallic silver static bag. Although the static bag spoke to the high-tech companies that make up most of Diesel's clientele, it also played a nice counterpoint to the humble rag. "The hardest thing was finding the quantity of rags we needed," says Diesel's Lara Neathery. "We had to run around town to the auto parts houses, buying up all we could find."

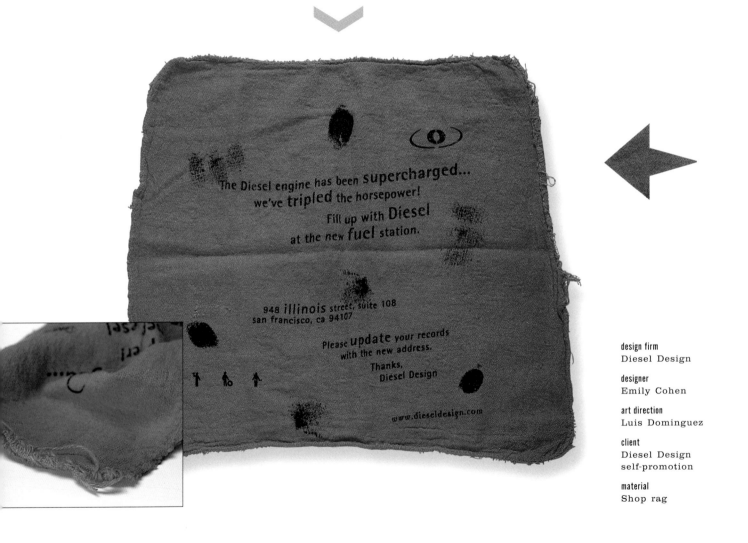

The Diesel engine has been supercharged... we've tripled the horsepower! Fill up with Diesel at the new fuel station.

948 illinois street, suite 108
san francisco, ca 94107

Please update your records with the new address.

Thanks,
Diesel Design

www.dieseldesign.com

design firm
Diesel Design

designer
Emily Cohen

art direction
Luis Dominguez

client
Diesel Design
self-promotion

material
Shop rag

design firm
Diesel Design

client
Diesel Design
self-promotion

materials
cardstock, metal can,
magnetic hook

1999 Calendar

As a leader in the Bay-area design community, Diesel has showcased the work of other designers since 1994 via giveaway calendars. Searching for inspiration for this piece, the Diesel Design team went to their tried-and-true font of inspiration: materials. "One of the things we do a lot around here is look through industrial-supply magazines," says founder Jeffrey Harkness. "We found the tins first—inexpensive but unique—and they became the initial idea. The question then became, 'How do we turn these into a calendar?'"

Recipients enjoyed the humor and insight in the Hopes and Fears in the New Millennium 1999 calendar, but it was the tactile design of the piece that kept Diesel's presence in hand year-round. "You have to interact with it day by day, rotating the month so that you can bring up the next day. It's fun and people enjoyed playing with it."

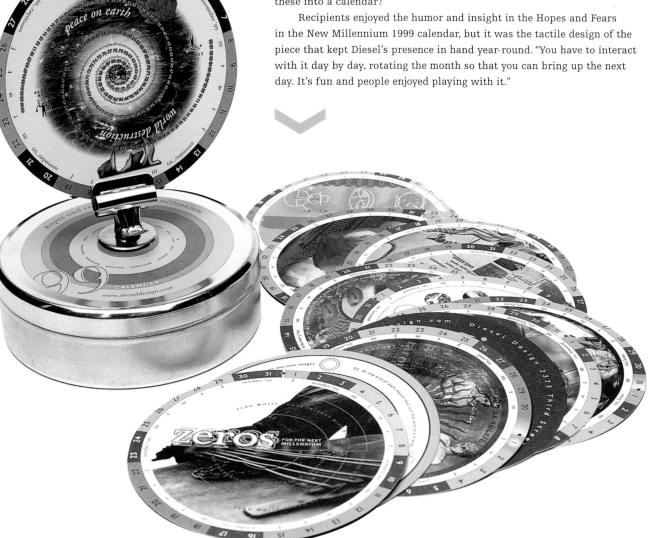

Occchi d'Occhi Postcards

These delightful google-eyed commemorative postcards were sold
in the gift shop of a Milan gallery exhibiting Steven Guarnaccia's work.
Guarnaccia is an illustrator, but he also works as a designer.

**"I was hoping to communicate, 'Hey, I also do this.' It's fun, and tactile
solutions are way out of the realm of the normal design commission for
a commercial client."**

(By the way, its pronounced "okee-dokee.")

design firm
Studio Guarnaccia

designer
Steven Guarnaccia

client
Studio Guarnaccia
self-promotion

materials
paper, google eyes

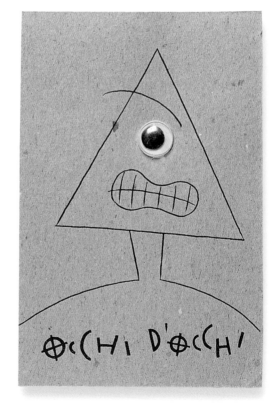

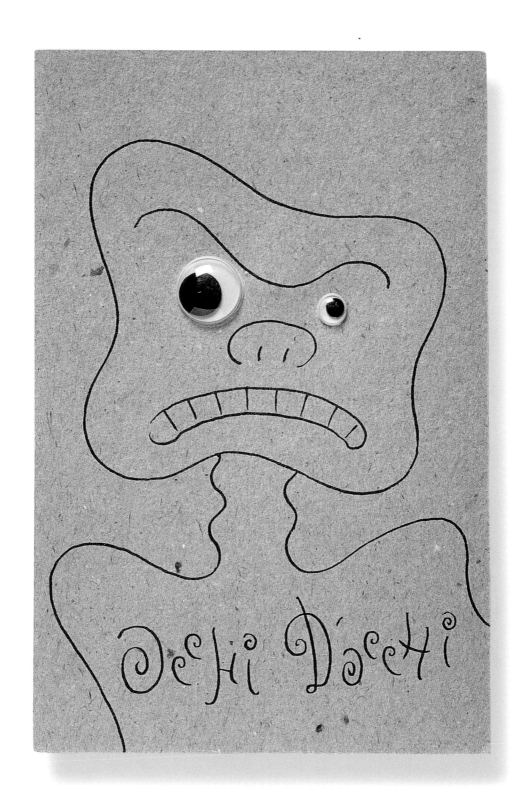

design firm
Gumption Design

creative direction
Evelyn Lontok

client
Gumption Design
self-promotion

materials
cardstock, metal ring

Fortune-Telling Calendar

"A friend of mine says if you find a playing card on the street always pick it up because every card has a fortune," says Gumption Design owner and creative director, Evelyn Lontok. With this in mind, she envisioned this witty self-promotion, a calendar based on cartomancy, or fortune-telling with playing cards.

Lontok and her design partner shuffled a deck of fifty-two playing cards and then assigned a week in the year to each card, in that order, with each month relating to a house in the zodiac. Likewise, each card suit offers meaning based on the house in which it appears.

For example, week fifty-two features the king of clubs, which implies self-destruction, while the House of Subconscious says, "Do not be confused by what others tell you about yourself. Stay your course."

Note that the calendar's size mirrors that of a miniature card deck that you might purchase at a gift shop, while the pattern on the back of each fortune mimics playing card ding-bats—only this deck sports Gumption's signature G logo. The back cover of this deck-of-cards-cum-calendar expands into an easel for display.

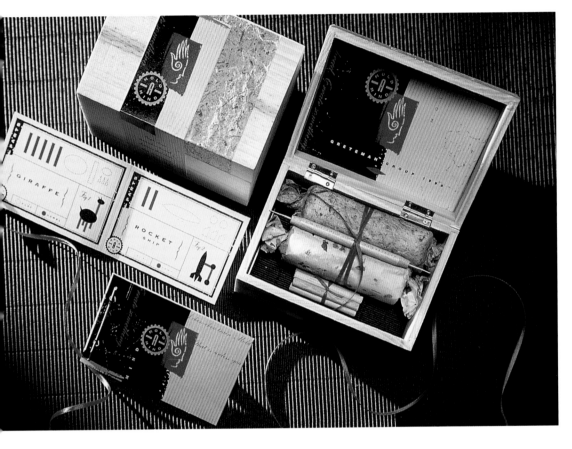

design firm
The Greteman Group

design/illustration
James Strange

art direction
Sonia Greteman

client
The Greteman Group self-promotion

materials
balsa-wood box, clay, molding tools, handmade paper

Mold-a-Mind Gift

Sonia Greteman, president and creative director of the Wichita-based The Greteman Group, has a holistic philosophy. This is not only evident in the meditative environment of the company's warehouse space and Greteman's own Eastern approach to living, but in the firm's self-promotions. Instead of sending holiday cards, for instance, Greteman each year makes a donation to a nonprofit organization in her clients' names. She and her staff then get to have fun creating a themed announcement that ties into that year's charity.

In 1998, the Group donated to an arts-related charity, and came up with this themed announcement, dubbed Mold-a-Mind. For these announcements, the designers aimed to not only please the eyes but also engage the hands, minds, and hearts of their clients. The balsa-wood box contains two blocks of molding clay and a booklet of whimsical instructions for making a train, a giraffe, and a rocket ship.

Spark-a-Star Millennium Gift

To celebrate the turning of the millennium, The
Greteman Group donated to a charity that offers oppor-
tunities to underprivileged students. Sparklers were not
only appropriate for the *fin de siecle* celebration but
also symbolized the charity, which "puts the spark back
in young people's lives."

The cover graphic represents the constellation Orion.
It was printed on a sticker and applied to the outside of
the silver tube; it also appears on the round, die-cut card
holding the ends of the sparklers inside the package.

> "We used an old-fashioned letterpress
> for the printing," Greteman adds. "The
> cool thing about a letterpress is that
> you can put gold and silver right on
> black and it gets pressed into the
> paper. It's a lost art that gives you a
> little deboss and almost looks metallic
> with these inks."

design firm
The Greteman Group

design/art direction
James Strange,
Sonia Greteman

illustration
Garrett Fresh

client
The Greteman Group
self-promotion

materials
aluminum tube,
sparklers, paper

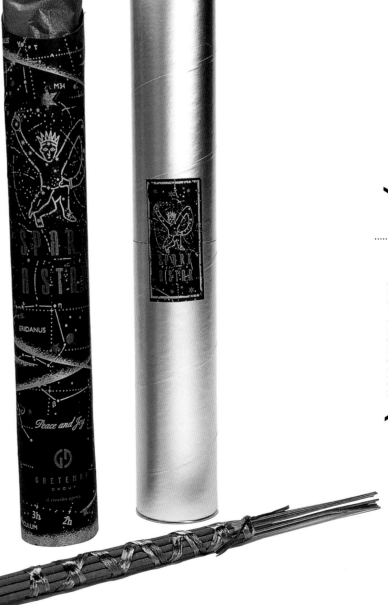

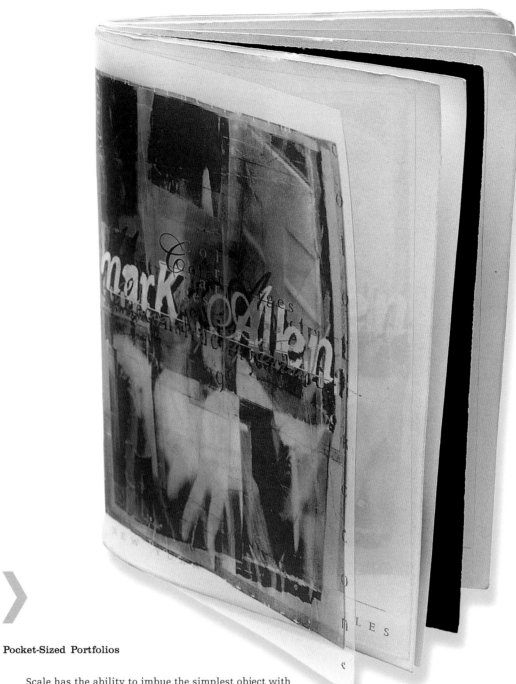

Pocket-Sized Portfolios

Scale has the ability to imbue the simplest object with must-touch tactility, as artist/designer Mark Allen discovered. Embracing his budget limitations to the nth degree, Allen shrunk his new portfolios to matchbook size and found that potential clients couldn't keep their hands off of them. "They just want to play with them and then put them in their pockets—which is fine with me."

design firm
Mark Allen Design

client
Mark Allen Design
self-promotion

materials
acetate, paper

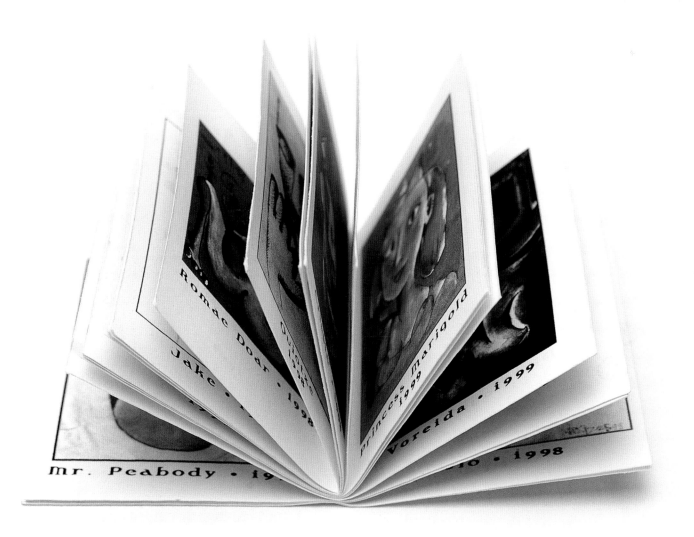

Paper Cut-Out Ornaments

When Darby Scott, a designer who built a name for herself as a "paper engineer", decided to create her own line of promotional giveaways, she returned to one of the most ancient tactile techniques: the cut-out. Perhaps most accurately described as sculpture, Scott's holiday cards have origins dating back to the second century when Chinese artists first began crafting paper. Scott printed these free-standing evergreens and snowflake ornaments on white matte cardstock with the added frosty effect of high-gloss white ink.

Scott designed an ink pattern and two custom pigments to adorn the paper slipcover case and envelope. White space was left on the inside flap of the envelope for customers to add a personalized message to the gift.

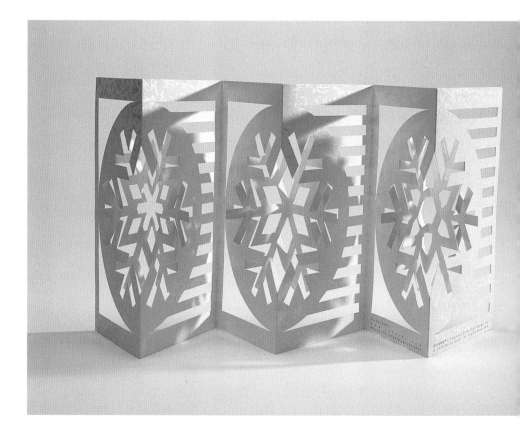

design firm
Unfoldz

designer
Darby Scott

client
Unfoldz self-promotion

material
paper

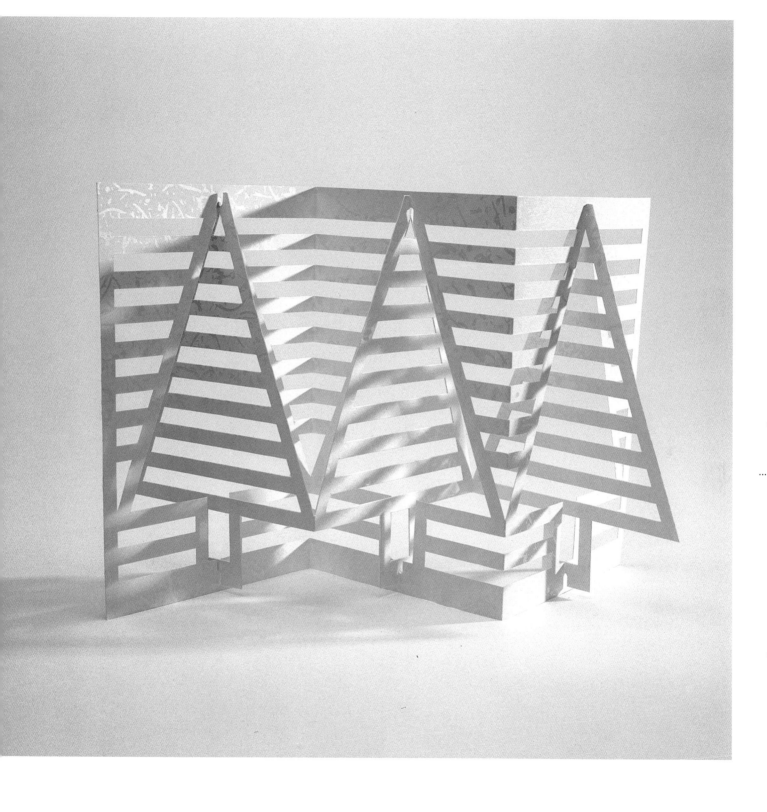

Al U. Minium Postcard

Steven Guarnaccia designed this aluminum postcard for New York's Purgatory Pie Press, a shop with a reputation for uncompromising handmade work. "They were printing artists' postcards using unconventional materials that challenged the Postal Service and their own presses. People could subscribe and get the cards in limited editions, signed and numbered. They're either expensive postcards or inexpensive prints, depending on how you look at it," he says. For Guarnaccia, Purgatory Pie's art retailing experiment was an adventure in tactile graphics and an opportunity to explore his interest in robots.

The cards quickly became collectible according to Guarnaccia, and so the U.S. Postal Service was spared the challenge of delivering Al U. Minium and his moveable jaw. Guarnaccia's potential clients got to play with Mr. Minium, however. "Anytime I do something in quantities, I send it to a select group of people as promotion."

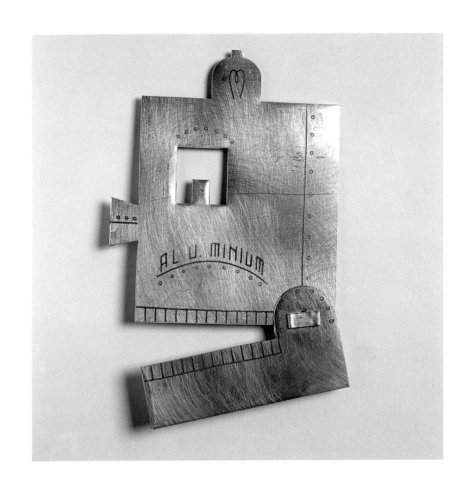

design firm
Studio Guarnaccia

designer
Steven Guarnaccia

construction
Purgatory Pie Press

client
Purgatory Pie Press

material
aluminum

meth*od*ol*o*gy 1999 Calendar

design firm
Chen Design Associates

designers
Joshua Chen,
Kathryn Hoffman,
Leon Yu, Gary Blum

creative director
Joshua Chen

client
Chen Design Associates
self-promotion

materials
matte cardstock,
bookbinding tape,
paper, elastic band

Every calendar is essentially tactile in nature, however some beg for more human attention than others. This Chen Design Associates' 1999 self-promotion strikes a sweet balance between function, sophistication, and touch-ability. There's just something about the clean, gray, matte cover with its black bookbinding tape and elastic band that makes you want to hold it—as if it is a precious text discovered after hours of toil in the Bodleian Library.

"We wanted to showcase different elements of good graphic design and present them in a systematic fashion," says Joshua Chen. "Like a lab experiment encased in a scientific notebook." Entitled meth*od*ol*o*gy, the calendar expresses basic principals such as structure, typography, and contrast in an intriguing layout that is at once retro and futuristic. Inside, and clipped into the metal fastener that holds the pages together, are instructions for turning the cover into an easel for display.

Chen split the cost of production with his printer, using a different paper for each month and allowing his vendor to provide the calendar as a giveaway.

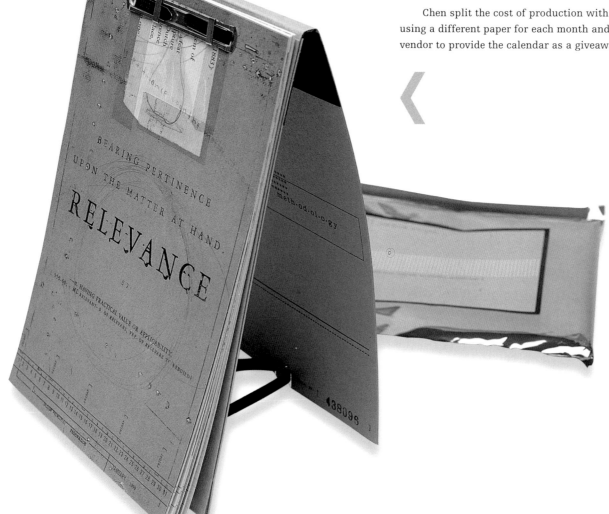
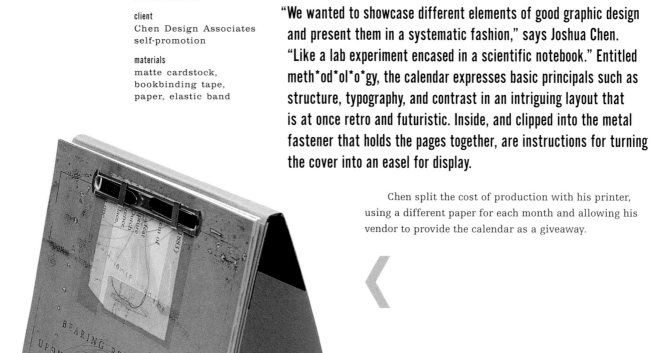

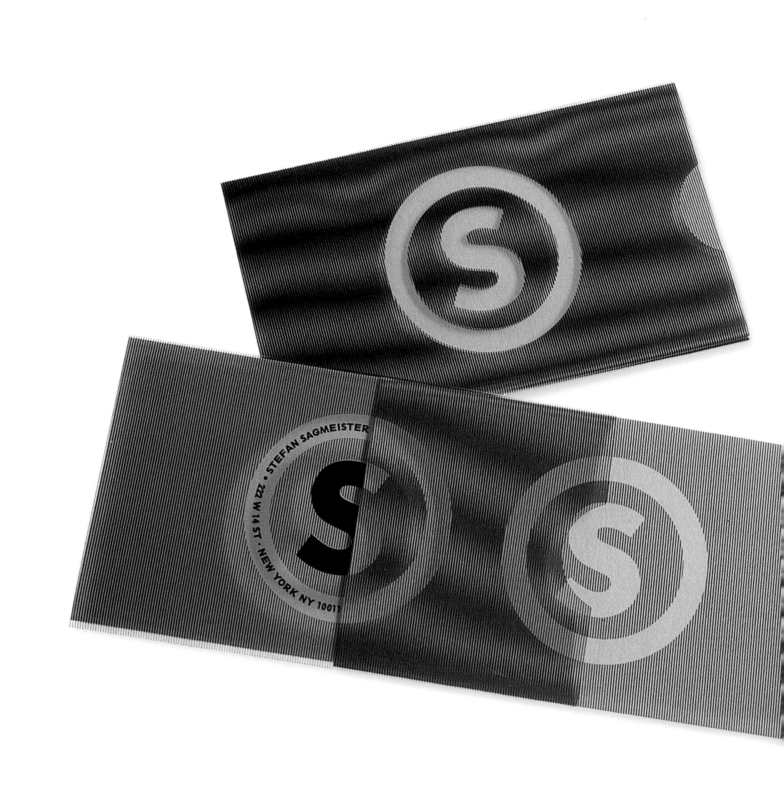

DIGGING INTO
IDENTITY

Creating a corporate identity system is a little like unearthing an ancient civilization. First, designers have to dig down to discover elements of the client's mission and mythology. Then, they have to haul all that material to the surface and figure out a meaningful way to organize and display it. **This chapter reveals creativity operating within an almost scientific framework, relying on research, acquired knowledge, and intuitive leaps of logic to synthesize masses of incongruous material into a single, potent symbol. Bravely, the designers featured here have all chosen to leave slick, 2-D corporate I.D. behind in their embrace of tactility.**

More than mere attention grabbers, the tactile elements in these designs amplify characteristics of the clients' identity in ways that 2-D graphics could not. Typically, they do this by *concretizing* the client's mission, as is the case of the whimsical business card for Playpen designed by Vrontikis Design Office. The card unfolds to become just that—a playpen. Or take designer Jason Ring's philosophical antibusiness card, a transparent envelope containing only possibilities. **In all these cases, the leap into 3-D space turns the design into an actual object, an artifact that, in the user's hand, makes the client's identity unforgettable.**

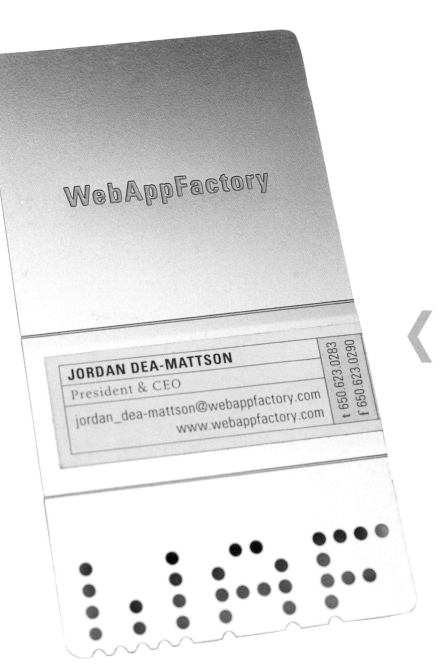

WebAppFactory Identity System

Joshua Chen, head of Chen Design Associates in San Francisco, explains that when he first met with client WebAppFactory, they emphasized their "roll-up-your-sleeves-and-do-everything" philosophy. "As a small start-up they realized the only way to make it was to pitch in and work together," says Chen. "So everyone from the CEO down to the newest person on the block has a factory kind of work ethic."

To conceive their identity system, Chen and designer Max Spector focused on WebAppFactory's made-in-America approach, juxtaposing it with the company's high-tech mission of creating custom database applications for new media.

The initials WAF are laser-cut into the letterhead, envelope, media kit, and business cards in an enlarged dot-matrix-type pattern that implies both the factory feel—almost as if any part of the system could be used as a punchcard—and the digital world in which the company works.

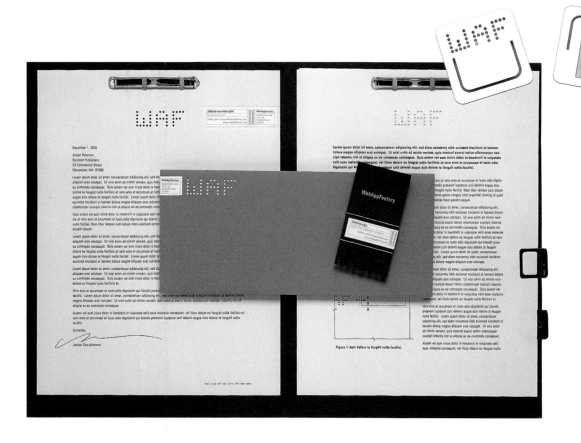

Chen added two budget-conscious elements to this package. First, the business cards and letterhead can be customized through the addition of laser-printed peel-off labels containing employees' contact information. Second, note the quirky paper clips: While working with his metal shop to create the business cards, Chen noticed leftover space on the 20" x 30" (51 cm x 76 cm) sheet set-up. Feeling playful, he filled up every spare inch with paper clips designed in the shape of the company's logo.

design firm
Chen Design Associates

designer
Max Spector

creative/art director
Joshua Chen

client
WebAppFactory

materials
paper, custom
paper clips

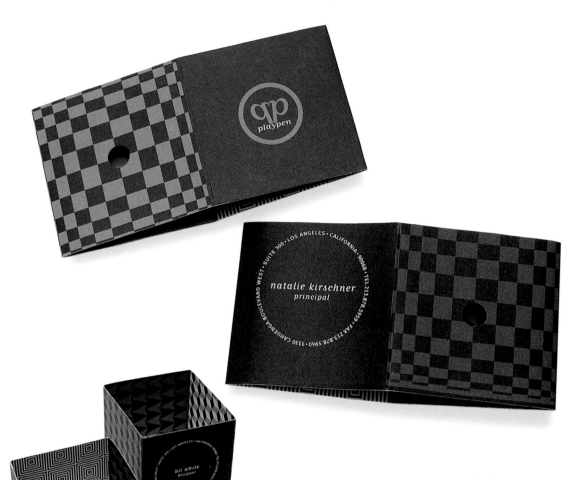

design firm
Vrontikis Design Office

client
Playpen

material
cardstock

Playpen Business Cards

Tactile graphics not only invite alternative materials but also the use of traditional materials in new and unexpected ways. When applied to something as ubiquitous as a business card, for instance, the matter-of-fact becomes something truly extraordinary.

A guiding principle of the broadcast graphics company Playpen is that their clients should have as much fun working with the firm as the firm has working on projects. "It was like they were saying to their clients, 'Come play in our sandbox,'" says designer Petrula Vrontikis, who took Playpen's slogan, Design with Fun in Mind both literally and tactile-ly.

Although at a distance they appear to be rather plain, solid-color business cards, in the hand they pop open, revealing themselves to be 3-D playpens. Peering into the tiny peephole, users see the company's motto printed on the inside. This design embodies the spirit of tactile graphics, putting the message in the mind by first putting it in the hand.

"These were expensive," Vrontikis says, "because the client wanted four different colors of the same card, so we did a run of four-over-four, then had them die-cut, then glued." Anticipating that the business cards would need to fit into cardholders, Vrontikis was conscientious about gluing and folding. "One of the things that helps designers with this kind of project is to have a printer's rep who enjoys the creative process," she says. "When they enjoy the process, they take care that things are done properly."

design firm
Sagmeister, Inc.

client
Sagmeister, Inc.
self-promotion

materials
paper, plastic

Moiré Screen Business Card

The moiré pattern that results from incorrect screen angles can be a problem in color-process printing, but a delight in a tactile graphic such as this business card.

Putting the science of optics to work for him, Stefan Sagmeister carefully plotted the extremely heavy moiré pattern to distract the eye—until his company's address is revealed by removing the card from its sleeve. "It comes as quite a surprise. As you pull the card out, first you see the S's go in different directions, then the address appears," Sagmeister says. "It proved to be a job-getter for us."

ANNI KUAN

242 W 38TH ST NEW YORK NY 10018 PHONE 212 704 4038 FAX 704 0651

018 PHONE 212 704 4038 FAX 704 0651

design firm
Sagmeister, Inc.

client
Anni Kuan

material
cardstock

Anni Kuan Business Card

You do it without really thinking: In the middle of an all-nighter you stop for no particular reason, pick up a toy off the desk—Gumby or a mini-Rubik's Cube or even a poor, dependable paper clip—and just play for a while. Tactile play returns us to a temporary state of grace. Sometimes, a remarkable design can be the record of that adventure in tactile innocence.

"The concept came out of boredom," Stefan Sagmeister explains. **"I was trying to come up with a stationery system [for fashion designer Anni Kuan]. I had the logo but nothing else, and I couldn't think of anything. I started cutting up the logo with an Exacto knife, and this is what came out of it."**

With a simple fold of this business card's two halves, the client's name becomes a delightful moment of discovery.

ring
jason
ring

646 242 7371

Anti-Card

"This is my antibusiness card, or noncard," explains New York designer Jason Ring. Inside this transparent envelope, where one expects to find a business card, there's only empty space. Upon receipt of the card, even knowing there is nothing in there, one can't resist opening the flap to check out the interior space. As Ring explains, you can look at his anti-card as an artistic joke or you can enjoy the "pragmatic and surprising experience" of storing something inside. Ring will include little gifts at times—"During the holidays I might put different things inside like pine needles. Sometimes I include really small samples of my work. But mainly I like to hand it out empty."

designer
Jason Ring

client
Jason Ring self-promotion

material
vellum envelope

Chen Design Associates Ephemera

"I hate standard paper clips. They can ruin the whole look of a presentation," says designer Joshua Chen. His company's logo, with its intersecting circles, provided a wonderful opportunity to riff on paper clip design. Throughout this identity system, Chen emphasizes movement and the appeal of contact. "We talk a lot about intersections—intersecting our talents with what our client is looking for. Here, we visually interpreted that using a variety of techniques. The thick, 100 percent cotton paper we chose for our business cards is offset printed in orange, then letterpressed in gray. On the back, the contact information is blind embossed. The objective was to make it all resonate, so that people would want to run their fingers over the surface of the letters. This adds to the whole intersection idea, creating an interaction between the reader and the sender."

Chen says that the additions of a metallic cardholder and the funky circular paper clips tie in thematically with the warehouse environment of his office space.

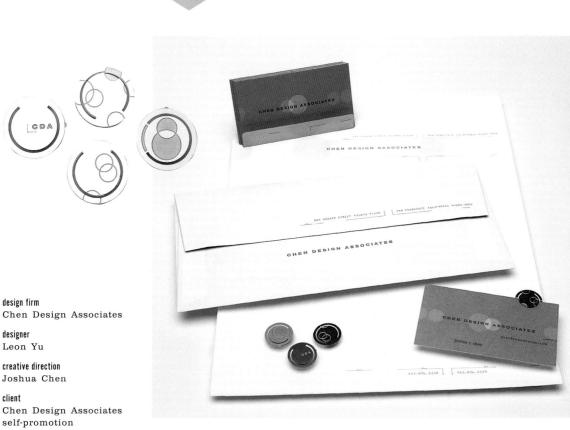

design firm
Chen Design Associates

designer
Leon Yu

creative direction
Joshua Chen

client
Chen Design Associates
self-promotion

materials
paper, custom paper clips,
cardholder

designer
Julie Garcia

client
Julie Garcia
self-promotion

material
die-cut aluminum

Aluminum Business Cards

This capricious aluminum business card embodies opposites: designer Julie Garcia's bold use of materials and her cute mouse logo. "I like the idea of something so soft on something so hard," she says.

"The small type was a challenge for the metal shop. The screen kept falling apart on the metal, so they had to be very careful. Especially with the mouse whiskers on the back," she says.

BLU DOT

HEATHER CARROLL

FURNITURE@BLUDOT.COM WWW.BLUDOT.COM 3306 5TH ST. N.E.
MINNEAPOLIS, MN 55418 **TEL 612.782.1844** FAX 612.782.1845

BLU DOT

HEATHER CARROLL

FURNITURE@BLUDOT.COM WWW.BLUDOT.COM 3306 5TH ST. N.E.
MINNEAPOLIS, MN 55418 **TEL 612.782.1844** FAX 612.782.1845

design firm
Fame

designer
Stuart Flake

client
Blue Dot

materials
card, cellophane wrapper

Blue Dot Business Card

"Last year, Blue Dot's trade show booth had a Habitrail with live gerbils. They like to make a strong presence," says designer Stuart Flake.

At trade shows, business cards are as common as coffee breaks. Commissioned to design a business card that wouldn't get tossed, Stuart Flake made what he calls, "The plainest card you could possibly imagine, just type on one side." Then he gave the card tactility by sealing each one in a nifty little transparent blue cellophane envelope. This provided aesthetic weight and a sense of value.

"We did the electrostatic sealing by hand. After a couple hours you've got enough for a trade show," says Flake, adding, "People who get the cards feel like they're being given a gift, which is powerful."

design firm
IDEO

designers
Johnson Chow (fortune
cookie), Monina
Dolan (blood), Rico
Zorkendorfer (seed)

client
IDEO self-promotion

materials
paper, plastic, metal, seed,
fortune cookie, pin

Miller Schwinn
79 Fifth Avenue
NY 10006
Tel: 201 209 3400
Cel: 917 601 1442
sweiss@msa.com

Scott Weiss
Personal Financial Consultant

Business Card Prototypes

These fascinating prototypes examine the possible future of the business card—the various forms of information a business card may have to deliver and the ways in which technology and culture will redefine traditional usage.

Created by artists from the San Francisco, Chicago, and London offices of design firm IDEO, these explorations consider topics of identity and corporate ritual. The Courtesy Blood Card: True Identity allows the bearer to more easily supply a blood sample to a new employer by pricking a finger on the little needle. The Seed Card takes a more symbolic tack, expressing the possible growth of new relationships by containing an actual seed. The elegant Fortune Cookie Card spills out festive fortune-sized strips of information.

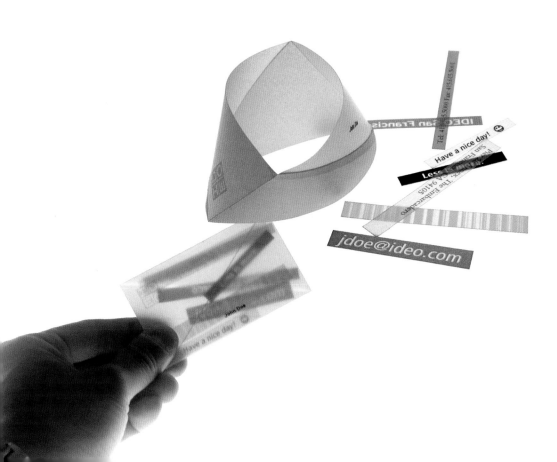

When a client approves a tactile design, the first thing the artist does is check to see how the stars were aligned. Almost every designer we interviewed explained that because tactile projects often require handwork or small print runs, it's a rare day indeed when a tactile graphic gets the go-ahead. Yet, the designers featured in this chapter were able to align their stars through clever strategies. For example, when the American Craft Museum asked Ken Carbone to design a fund-raising piece to be sent to the museum's entire mailing list, Carbone countered with a suggestion. Rather than blowing the budget on 2-D mailers sent to thousands, why not invest in an irresistible, tactile design that one could be certain would surely get into the hands of the few hundred people who could actually donate a million dollars or more? The success of the campaign was a testament to the power of this type of design. Not only are tactile graphics good strategy, but they can sell an idea that is otherwise difficult to express in narrative terms. How do you, for instance, sell a movie idea when the concept is so visual it can hardly be explained in words? As you'll see, 44 Phases put the concept for *The Cell* into objects and images that could be held in a development executive's hands. When designers step beyond two dimensions into tactility, the resulting objects are more likely to be displayed on bookshelves than tossed into file thirteen.

MESSAGES
from the THIRD DIMENSION

American Exotica/The Cell Treatment Presentation

In Hollywood, everybody's got a movie project to sell, and each week producers hear dozens of pitches from would-be _auteurs._ Given this constant barrage of great ideas, even the most open-minded executive can get a little hard-of-hearing. Gearing up to pitch Tinsel Town, director Tarsem Singh decided he needed a new approach for his pet project, a bold stylistic twist on the psychological thriller genre. At the time, Singh's project was called _American Exotica_, but it would eventually be released as _The Cell_, one of the most visually stunning feature films of 2000.

Singh's quest for a new type of presentation brought him to Los Angeles designer Daniel Tsai. "Tarsem needed a way to make his ideas tangible," says Tsai. "He threw it open to us to do whatever we could to make the movie real to the people he was pitching." Working with designers Staci Mackenzie, Kurt Parker and Daniel Garcia, Tsai found a remarkable tactile graphics solution and in the process literally began a revolution in the way directors sell film projects.

Studying _The Cell's_ powerful, dreamlike symbolism, the artists imagined the film as a container filled with objects in unlikely juxtapositions that add up to an emotional whole, something akin to the box constructions of New York surrealist Joseph Cornell (1903–1973). They saw the container as a leave-behind that would underscore the emotional and symbolic power of the script and the director's vision. Tsai describes the conception as "a box of daydreams and memories that the main character took with her when she was growing up."

Inside the elegant hardwood box, a ribbon draws the user through the layered contents like a narrative thread. Photographs, bits of fabric, handwritten letters, even a rare, luminescent butterfly are the tactile remains of what poet W.B. Yeats called the "rag-and-bone shop of the heart."

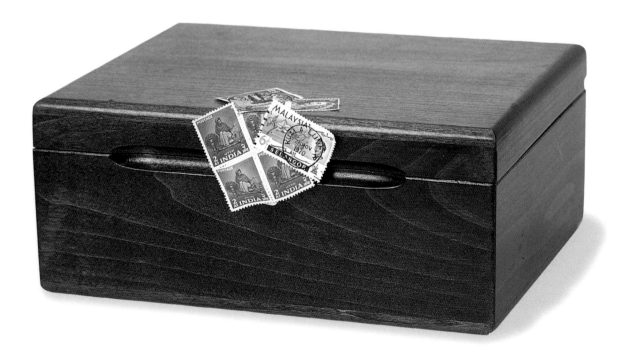

design firm
44 Phases

designers
Daniel H. Tsai, Staci
Mackenzie, Kurt Parker,
Daniel Garcia

client
Tarsem Singh

materials
hardwood box, paper,
photographs, xerography,
fabric, butterfly, fabric
trim, assorted artifacts,
postage stamps

The designers began by writing a sentence to symbolically describe the action of each scripted page, one sentence per page. "Then we each pulled out one sentence and went to work illustrating it." The next step in constructing the package was to mock up a prototype of the box and then commission a carpenter to realize it. The finished piece was completed in ten days and employed over 75 vendors, including printers, color copyists, papermakers, a calligrapher, a seamstress, a hand letterpress typesetter, and a butterfly collector.

The combination of Singh's vision and the irresistible design enabled *The Cell* to eventually find its producer, New Line Cinema. To date, the team that eventually became the Los Angeles-based firm 44 Phases has made dozens of these "treatment presentations" for a growing list of clients.

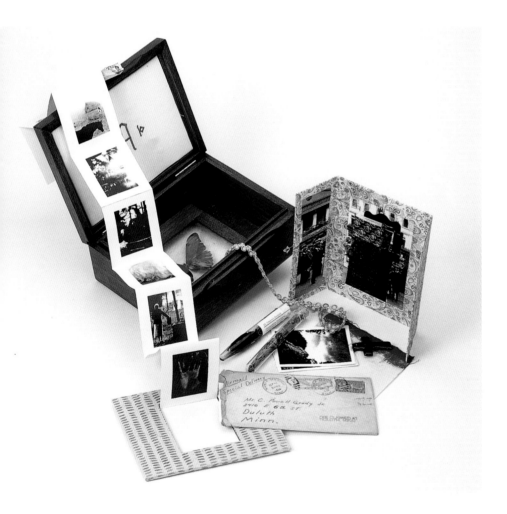

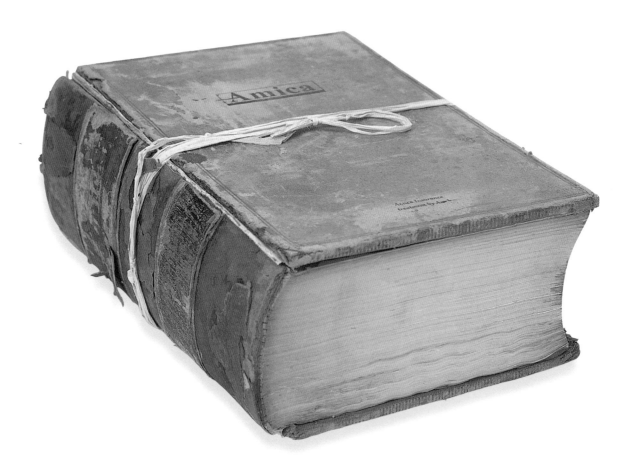

Amica Insurance Treatment Presentation

44 Phases was approached by a commercial director who was pitching a Midwestern insurance company specializing in disaster policies. "The director had an idea but he didn't know how to translate it into a conference call, so he came to us," says designer Daniel Tsai. "Insurance is about foreshadowing events that could happen, and so we tried to make that concept real."

The 44 Phases designers hollowed an oversized antique book to serve as a container. Next, they collected what Tsai describes as, "Memories retrieved after a disaster, which describes what the insurance company does." To the user, these objects read like clues: rusted and burned heirlooms, bits of twisted metal, the scattered details of a life. Most powerful of all is a series of transparencies, which when held up to light, reveal images of looming catastrophe.

Because the container is a book, it suggests that the contents will tell a linear tale, an assumption subverted as soon as the cover is opened. Inside, the user examines successive strata of haunting objects in a non-sequential, emotional archaeology. The sensuality of the Amica treatment presentation communicates an emotional complexity that would have been inexpressible on a 2-D surface.

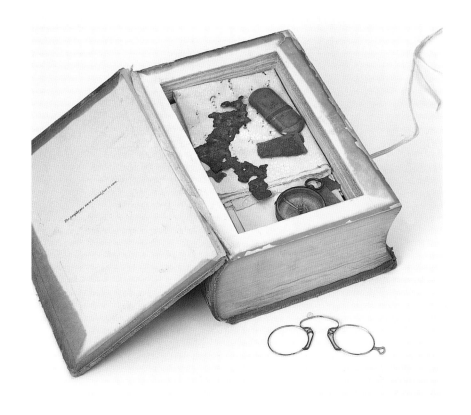

design firm
44 Phases

designers
Daniel H. Tsai,
Karen Orilla

client
Amica Insurance

materials
antique book, paper,
transparencies, fabric,
assorted artifacts

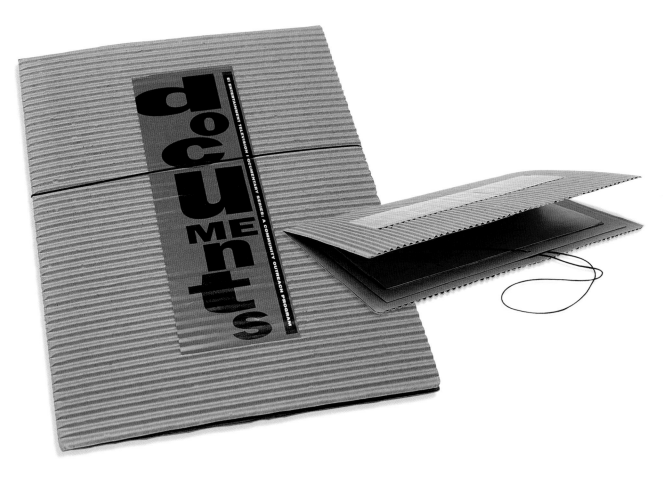

design firm
Vrontikis Design Office

creative direction
Petrula Vrontikis

client
E! Entertainment
Television

materials
e-flute, elastic cord,
paper, chipboard, label

E! Documents Kit

Asked to create an outreach package to promote an E! Channel documentary series to schools and libraries, Petrula Vrontikis saw in the project's budgetary constraints an opportunity to subvert a design trend through the power of tactile graphics. Studying similar media kits in the market, she found a preponderance of slick graphics and chose instead to steer her project against the grain. "I chose the e-flute material because it's inexpensive, and it's also so powerful in its simplicity."

"Generally, I have found that when I have to make only a small quantity of something, it enables me to think about alternative materials," says Vrontikis, a Los Angeles—based designer and Art Center College of Design instructor. "Alternative materials often come out of tight budgets."

The folded e-flute is stabilized with chipboard, providing a gritty, pragmatic feel that parallels and amplifies the real-world nature of the documentary series. The simple elastic cord and its cover label are also integral elements of this economical, elegant package, of which only one thousand were produced. The cord closes the cover with flair rather than pricey fasteners, and the clean lines of the inexpensive label give the overall package a sophisticated look. As Vrontikis describes it, "The whole thing looks much more elaborate than it actually is."

Boeing Business Jets Invitation

It took six vendors to complete this eighty-unit promotional project and a load of creative brainpower on the part of graphic designer Henry Yui and his team at Seattle-based Hornall Anderson Design Works, Inc. Created to promote custom-designed interiors for corporate jets, this exquisite catalog features a leather slip cover, wood laminate back, embossed paper, photos, a velum overlay, and metal etchings.

Says Yui, "The CEO of Boeing wanted a small piece that he could give to *Fortune* 40 CEOs that reflected luxury, usability, and function, but still felt like a work in progress." Thus, the pages of this promotional piece fan out like a swatch paint chip-book, depicting the workmanship and detail available in each section of the aircraft cabin. The use of metal and wood suggest the solidity of the jets. The leather slipcase has the luscious feel of a fine Italian wallet, while the small size lends the piece an heirloom quality.

Although Yui only had a month to take this project from concept to manufacture, he admits it was quite a coup as he was awarded both a substantial budget and extensive creative freedom. Even under such lavish circumstances, he is quick to add, the smallest job can still be one of the toughest. "The pitfall with a project like this," he says, "is to overdesign."

design firm
Hornall Anderson Design
Works, Inc.

client
The Boeing Company

materials
wood laminate, leather,
paper, vellum, aluminum

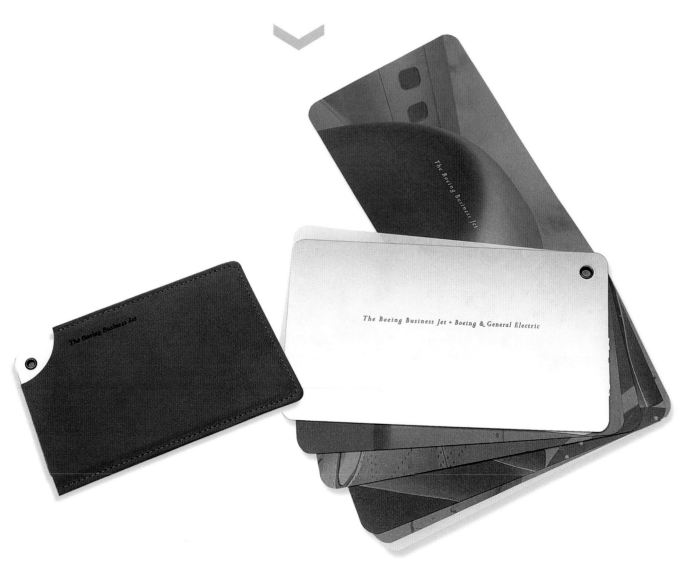

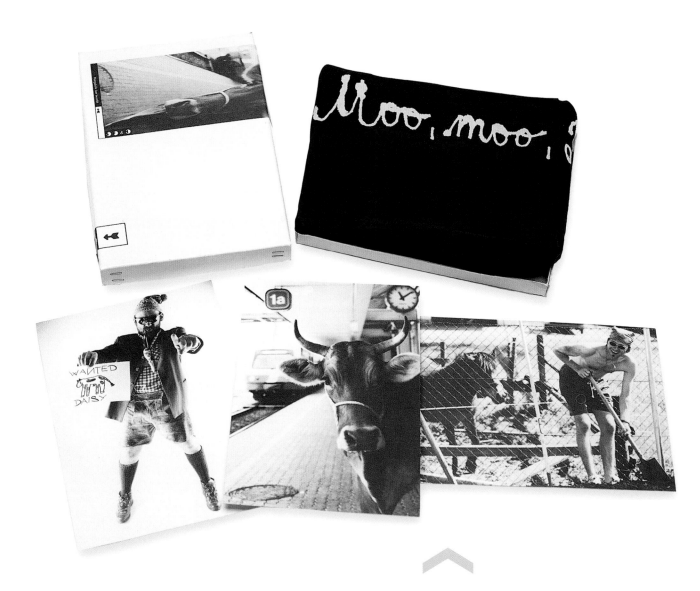

design firm
Atelier Für Text
Und Gestaltung

design/concept
Hermann Brändle, Kurt
Dornig, Sigi Ramoser,
Sandro Scherling

client
Fotostudio Fotolabor
Paintbox

materials
fabric, cardstock,
cardboard

Moo, Moo, Daisy

According to Sigi Ramoser of Germany's
Atelier Für Text Und Gestaltung, this
whimsical piece was created to attract
the eyes—and fingers—of German fashion
designers to their client, the elite photo
house Fotostudio Fotolabor Paintbox.
Instead of a typical portfolio-style
brochure, this tactile piece invites recipi-
ents into the wonderfully silly adventures
of Daisy the Cow, a bovine beauty who
"wants to become a model in the big city."

The silky black rayon is printed with
Daisy's dairy ... er, diary... entries, describ-
ing her adventures in search of supermodel
stardom. This *memoir de moo* is shipped
in a tidy white box and includes a candid
shot of the determined Daisy. (Note the
ironic poignancy of her pouting lips and
innocent, cow-next-door charm. She'll set
the fashion world on its horns.)

Smith Sport Optics Display and Packaging

This point-of-purchase display uses natural material in an unexpected way; first by sandblasting the rock component to leave an embossed image, rather than a debossed one, and second by allowing the fastening tape and metal rivets of the boxes to remain exposed, suggesting forthrightness and honesty.

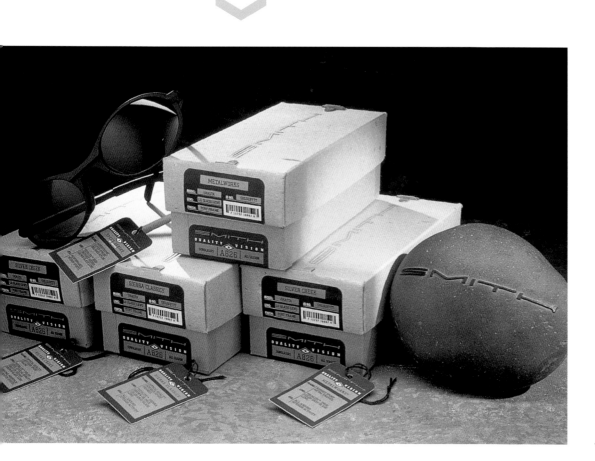

design firm
Hornall Anderson Design Works, Inc.

designers
Jack Anderson, David Bates, Cliff Chung

client
Smith Sport Optics

materials
debossed stone, cardboard, rivets

5 x 5 Jahre Schulheim Mader

Peter Felder says that production was much more difficult than concepting for this beautiful jewel case. The CD was made to celebrate the twenty-fifth anniversary of a hostel for handicapped children, whose singing is featured on the CD.

The jewel case employs a tactile design that prompts the user to remove the liner notes, which creates an elegant, playful illusion. Explains Felder, "If you take out the booklet you see five colors. Putting it back into the sleeve creates twenty-five new colors. Each of the twenty-five colors stands for one year of the Schulheim Mader hostel. The single colors—five on the booklet, five on the CD cover—symbolize the handicapped children and the therapists.

[Working] together, something new can arise in their daily work, play, and caring for each other—new colors, a new fullness of life."

Yet Felder adds that offset printing five colors onto acetate wasn't easy. The colors kept running together, so they were forced to experiment with different materials until they finally discovered an acetate—the type used for overhead projections—with enough absorbency to hold the ink. As it was impossible to cut the plastic by machine, Felder and his team were forced to hand-trim the five hundred inserts.

design firm
Felder Grafikdesign

designers
Peter Felder,
Sigi Ramoser

art direction
Peter Felder

client
Schulheim Mader

materials
paper, acetate, jewel case

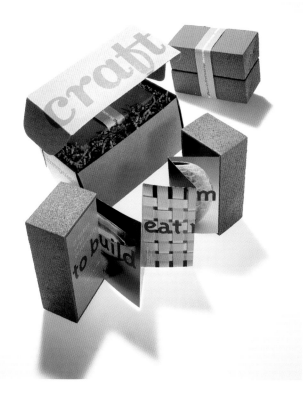

design firm
Carbone Smolin Agency

creative direction
Ken Carbone

art direction
Justin Peters

client
American Craft Museum

materials
cardstock, foam brick

American Craft Museum Direct-Mail Campaign

Evidenced by this elegant fund-raising piece, the work featured at the American Craft Museum should be categorized as fine art. Carbone Smolin Agency cofounder Ken Carbone explains that when the museum first pitched the idea of a direct-mail piece to raise funds for the purchase and redesign of its facility, fundraisers had settled on a twenty-five thousand–run, number ten envelope-size brochure. Carbone, however, questioned positioning the museum with a mailer that might not live up to the quality of exhibitions found inside the walls of the facility.

"I asked the director how many people on that list could actually write a one million dollar check? It turns out only about five hundred of them could, so I suggested taking that same budget and putting it into five hundred pieces that would stop people in their tracks. Something with real personal appeal. Something that positioned the organization as a winning investment." The result? A stunning gift box enclosing a design object worthy of display.

Carbone felt that two bricks, encased in the gift box, would speak to the museum's need for physical expansion and serve as the cover for this unique accordion-fold brochure. After finding a foam-brick manufacturer through a movie prop house, Carbone had the bricks custom cut and painted. Adds Carbone, "Since we couldn't control how people might open the brochure, we wrote the text in a circular fashion." If you open the brochure one way it reads, "To build a great museum" on the front and "It takes more than bricks" on the back. If you open the brochure the other way, it reads "It takes more than bricks" on the front, and "To build a great museum" on the back.

Carbone also suggested overrunning the printed brochure and using it as a stand-alone.

designer
Carmen Dunjko

client
Bryce Duffy

materials
cardstock,
black rubber band

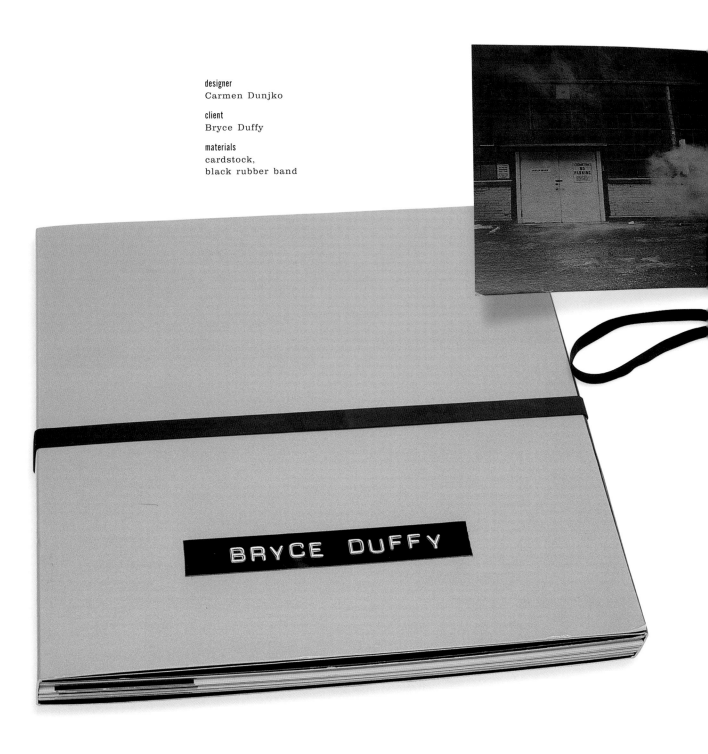

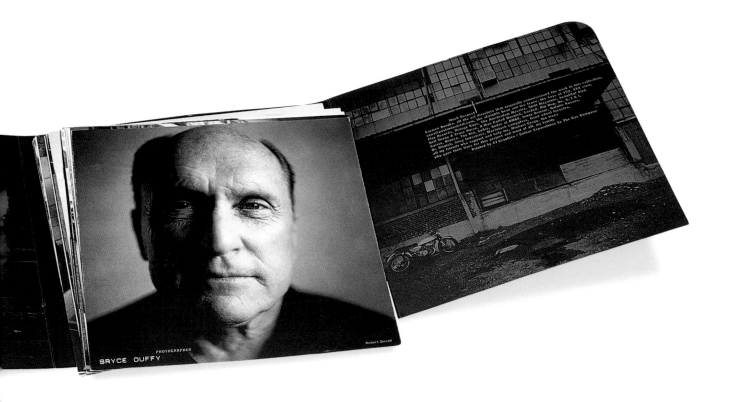

Bryce Duffy Brochure

Photographer Bryce Duffy was making a living as a commercial photographer, but just barely. Kicking his career into overdrive, he knew, would require a high-powered portfolio. Designer Carmen Dunjko found that power in tactility.

"Bryce's work is all about engaging the people that he's photographing," Dunjko says. "He doesn't try to control the situation, but rather attempts to bring out an honest dialogue." She set out to embody that dialogue in a design that would invite interaction.

"I wanted to get as close as possible to the feeling that you're looking at a contact sheet, so that the art director feels that they're in a process, that they're making editorial decisions."

Dunjko wanted art directors to see the portfolio as something *useful*, a practical problem-solving device. Her solution was to leave the photos unbound, so that art directors could order them as needed for a particular pitch. This also served a practical purpose, simplifying what would have otherwise been a printing nightmare. "To do something like this would have been a twelve-color job if it had been bound, but because it was [made up of] individual parts it was easier to change plates and change inks. We came up with a formula where certain sheets were printed in color and some in quadratone. It was complex. The color separator embraced the craft, which was really helpful."

The heavy stock imparts Duffy's straighforward, photojournalistic style, and ditto the black rubber band. "Finding the rubber band was the hardest part," Dunjko says. "We ended up contacting suppliers in the music business. It's a belt for a turntable."

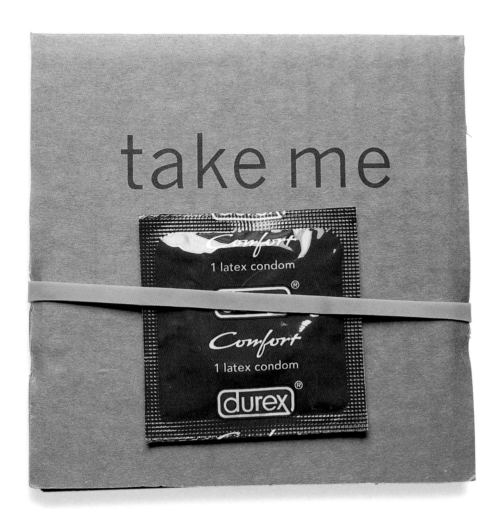

Terrence Higgins Trust Promotional for World AIDS Day

For a World AIDS Day celebration, the Terrence Higgins Trust commissioned London design firm Lippa Pearce to create a promotional piece about safe sex. Since the giveaway would be available with CD purchases at major retail stores like Tower Records, the Lippa Pearce team designed it to match the size of CD jewel cases.

Inside is a poster that Harry Pearce describes as "a mix of silly ideas" about sex. The real message—Protect Yourself—is punctuated by the addition of a free condom.

design firm
Lippa Pearce Design Ltd.

designer
Mark Diaper

art direction
Domenic Lippa

client
Terrence Higgins Trust

materials
cardboard, paper, rubber
band, condom

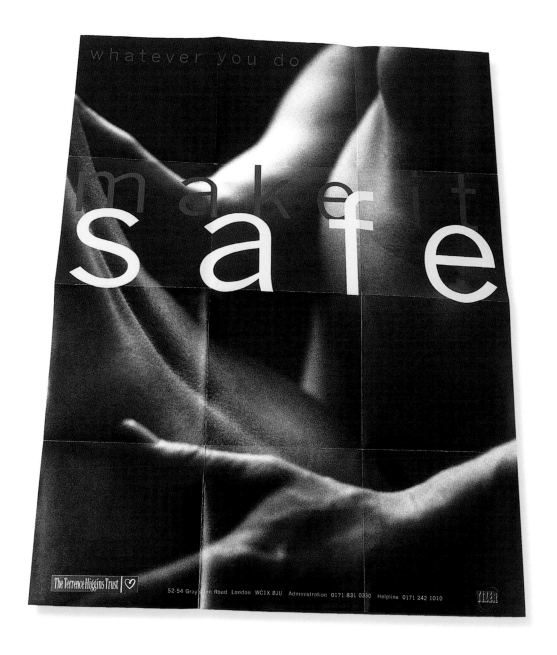

Ben Kelly Design Brochure

When Lippa Pearce Design Ltd. was asked to create a memorable brochure for Ben Kelly's world-renowned interior and installation design studio, the artists decided to focus on the multidisciplinary nature of his work. "Ben Kelly works with all kinds of materials," explains Harry Pearce. "Everything from rough concrete to found objects in the form of chevrons— all kinds of oddities from his wanderings out and about. So our idea for this book was to bring together all kinds of binding processes and paper stocks. Some parts are printed, some are silk-screened, some are lithographed. I think we ended up with six different printing processes, six different materials, and three different folding methods. Together, they sum up how Kelly works."

Of course, Pearce admits, they also drove their printer—as Londoners say—barking mad.

design firm
Lippa Pearce
Design Ltd.

designers
Harry Pearce,
Jeremy Roots

art direction
Harry Pearce

client
Ben Kelly Design

materials
cardboard, plastic,
paper, spiral binding

Cultural Industry—Now You See It Programs

For the South Bank Festival of Arts called Now You See It, the Lippa Pearce design team created a program that changed its costume with each performance. Although the contents remained the same for each show, each performance received a cover that spoke to its unique personality. So, the comedian with rough edges had a sandpaper cover, the jazz ensemble was represented by midnight blue plastic, and the ballet dancer was celebrated with a delicate, recycled paper stock. For the audience, these keepsakes became an integral part of the performance, tactilely defining the diverse soul of the festival.

design firm
Lippa Pearce Design Ltd.

designers
Mark Diaper,
Domenic Lippa

art direction
Domenic Lippa

client
South Bank Festival
of Arts *Now You See It*

materials
corrugated cardboard,
various handmade papers,
sandpaper, paper lining
material, paper, plastic

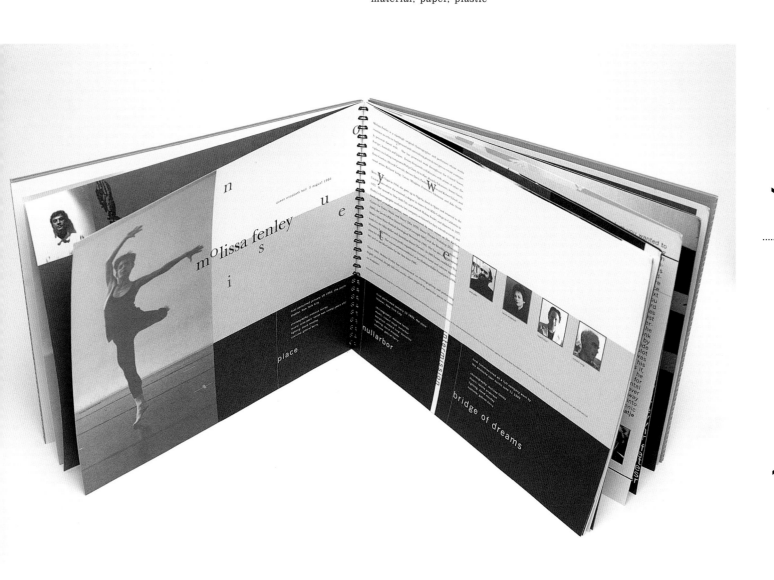

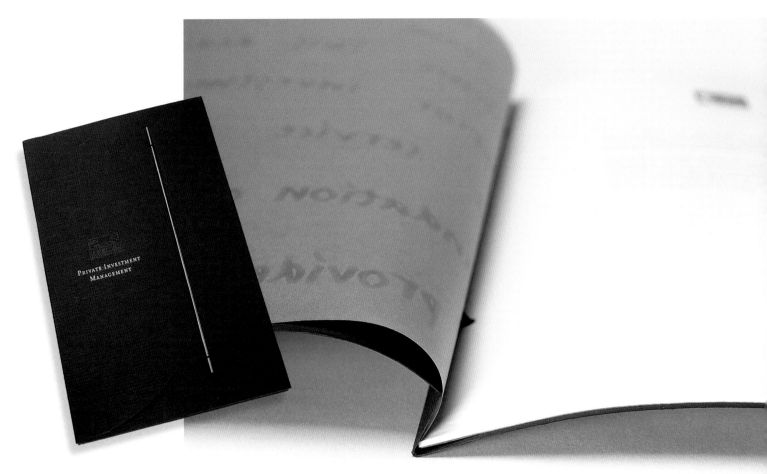

design firm
AGF Funds, Inc.

designers
In-house team

client
AGF Funds, Inc.
self-promotion

materials
duplex paper,
paper, brass rod,
rubber bands

AGF Funds, Inc. Promotional Brochure

If it weren't for the extraordinary craftsmanship of vendors like CJ Graphics in Toronto, Canada, pieces like this exquisitely sophisticated brochure would never make it from concept to completion.

AGF, one of Canada's largest wealth management firms, came to CJ Graphics with a relatively simple idea for this oversized piece, but they needed the printer to complete several tricky elements. The gold lettering, for example, is not only embossed but also foil-stamped. Likewise, the stock is a duplex of matte black and cream. An additional touch of refinement is added by the thin brass rod, which does double duty as a closure element and a binder for the contents.

Finished in printed vellum, the overall look speaks of both the spare elegance of the Far East and the power of Wall Street.

Bridgetown Promotional Calendar

This inventive calendar was designed to keep the Bridgetown Printing Company's name in their clients' hands year-round. "The clients received the metal stand and the first month's calendar in a box with a card explaining that the rest of the calendar would come throughout the year," Dotzero's Jon Wippich explains. "We wanted each month to be a completely different look, and since this was a millennium calendar, we based each month on a decade of the previous century, plus two bonus months that were about the future."

The style of each month is drawn from the decade it represents, so the 1900s are represented by a playful Western style, the teens by flashy Art Deco, the '30s by Art Nouveau, etc. "It was fun finding different ways to approach each piece," Wippich adds. From collage to tinting to painting, Dotzero got to throw the graphics kitchen sink at this project.

For the elegant metal stands, Wippich went back to a familiar vendor. "The same metal cutters who did our Aluminum Man business card holders (see page 53) did the calendar stand," Wippich explains. "They'd never had to bend metal to this severe an angle before and cutting out lettering that small was pretty challenging, too. We had to keep trying till we got it right."

Wippich concludes, "People can always tell when some thought and handwork has gone into something. That gives it value."

design firm
Dotzero Design

design and illustration
Karen Wippich,
Jon Wippich

client
Bridgetown Printing
Company

materials
cardstock,
die-cut aluminum

/Su01 02 03 04 05 06 07 **Su**08 09 10 11 12 13 14 **Su**15 16 17 18 19 20 21 **Su**22 23 24 25 26 27 28 **Su**29 30

**/Printed on Solaire 135 gsm

Robert Horne Paper Company Calendar Promotion

To lend impact to paper manufacturer Robert Horne's Design Consultants promotional calendar, the London design firm Navy Blue created a tactile slight of hand.

The overall effect of this piece is a dynamic embodiment of the differences between sighted and nonsighted experiences of the same object. Ostensibly, the calendar tells the story of a garden's changes of season. However, the garden on which the calendar is based is a London sensory awareness park for the disabled. Like the park, the calendar demands tactile interaction.

As the calendar progresses from front to back, blind users find increasing amounts of tactile information in the form of Braille and die-cuts. Conversely, information for sighted persons increases as the calendar is read from back to front. Yet, heat- and light-sensitive inks cause the text to quickly disappear from vision, giving sighted users an experience of the nonsighted world.

The Royal National Institute for the Blind was consulted on the project.

design firm
Navy Blue Design
Consultants

designer
Clare Lundy

creative director
Geoff Nichol

client
Robert Horne
Paper Company

materials
paper, heat-and-light-
sensitive inks

Hotjobs Matchbook Mousepad Mailer

When inspiration strikes, it makes sparks. When designer Evelyn Lontok's client hotjobs.com wanted to send out a mailer containing a mousepad, Lontok's first thought was this pun-ish packaging idea.

The hot-red matchbook was created by folding a single sheet of gloss laminated paper. The staple in the center of the matchbook's lip is a digital image, while the lip itself was tipped with glue to stay shut and hold the cover in place, just like the real thing.

design firm
Gumption Design

creative director
Evelyn Lontok

client
hotjobs.com

materials
gloss laminated paper,
mousepad

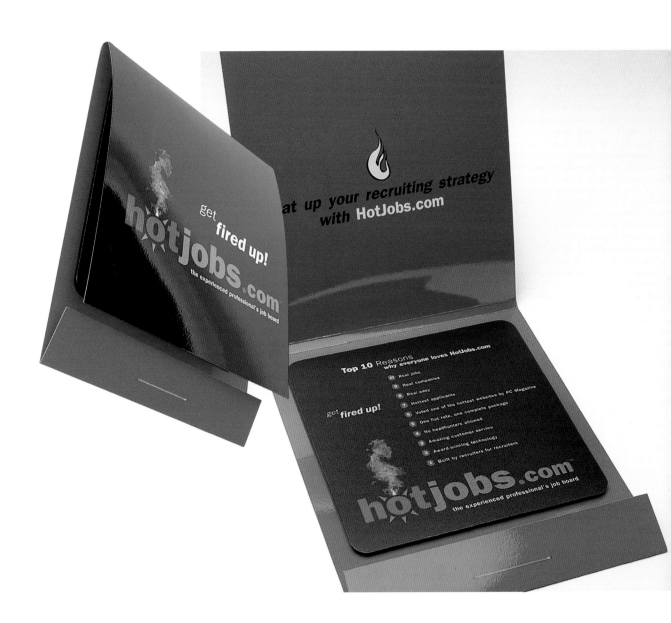

Flexjet Timepiece Brochure

design firm
The Greteman Group

design/art direction
James Strange,
Sonia Greteman

client
Flexjet

materials
cardboard, clock

Nothing could be more important to the business traveler than time, which is why The Greteman Group pitched the idea for this clock gift promotion to Flexjet, a company offering executives fractional ownership of private jets. "Fractional ownership is totally tied into time," explains creative director Sonia Greteman.

"Flexjet's clients can't afford to miss planes or be stuck in airports. It can literally cost them millions of dollars." With that in mind, what could catch a busy person's attention more than this clever timepiece?

Although Greteman had to practically scour the globe to come up with a reasonably priced clock mechanism, her design and Flexjet's twelve reasons-for-purchase fit together well: Each reason is printed on an hour of the clock.

Greteman had to keep close tabs on the intricate die cuts in this 20 lb. paper. Some thirty thousand clocks were produced—a very large number for a hand-assembled tactile design.

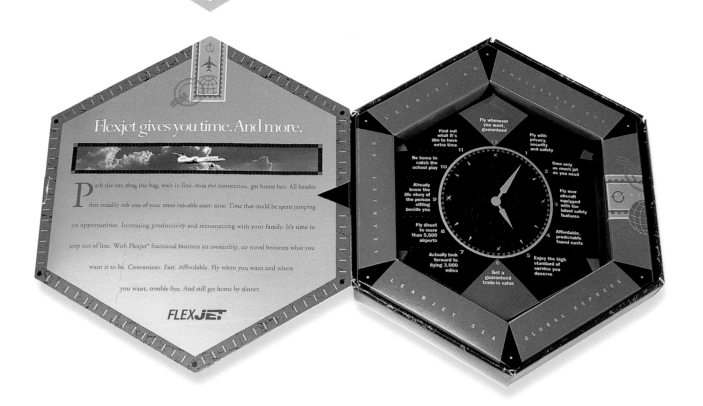

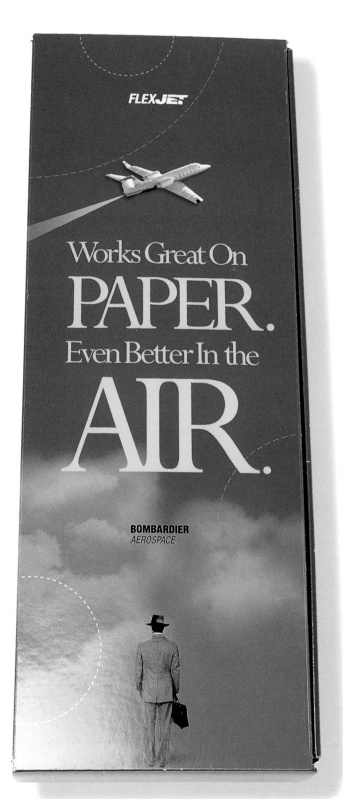

design firm
The Greteman Group

design/art direction
James Strange,
Sonia Greteman

client
Flexjet

material
paper

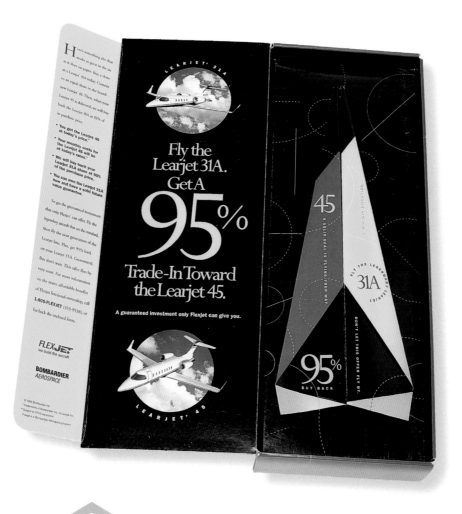

Flexjet Paper Airplane

Being a tactile designer can mean getting paid to make paper airplanes. For this promotion, client Flexjet, a corporation offering fractional ownership in jets, wanted to explain a new offer to potential clients. Flexjet provided the theme "Works Great on Paper, Even Better in the Air," which designer Sonja Greteman spelled out on the wings of this feisty little fighter. Says Greteman, "They're actually stunt planes. Depending on how you tip the wings, they'll loop or swirl."

Greteman based the design on hard research that included a lot of crash-and-burn testing, with airplanes made from the same press sheets and the same amount of ink that she planned for the final product. To further ensure airworthiness—and to get recipients right into the fun—after the planes were die-cut they were hand-folded and shipped preassembled.

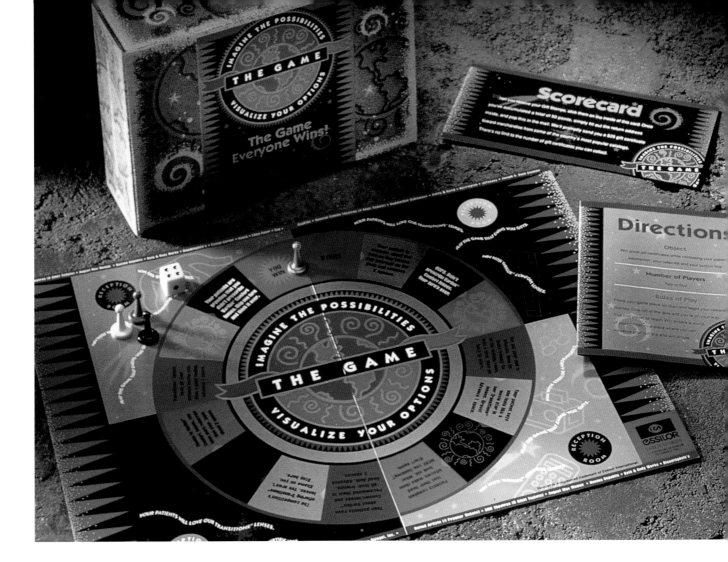

Duffins Optical Board Game

Duffins is an optical-supply house specializing in lens manufacture. In a unique spin on incentive marketing, the company decided to attract opticians to their products by playing around—literally. This game board, designed by The Greteman Group, helps players—the opticians—win points towards gifts every time they sell a Duffins product.

Note the use of stickers on the box—a simple work-around for hard-to-print-on surfaces.

design firm
The Greteman Group

design/art direction
James Strange,
Sonia Greteman

designer
Jo Quillin

client
Duffins Optical

materials
heavy board, labels

design firm
Boxer Design

designer
Eileen Boxer

client
Knoll.com

materials
cardstock,
lenticular lens

Knoll.com Launch Announcement

Having a lenticular piece in hand is
always good fun, tilting it back and forth to
read the changing messages. Perhaps the tac-
tile power of lenticular printing is that this
optical effect is often viewed from a distance,
so it's surprising to see that it also works
close up. Also, you just can't resist running
your thumbnail across that ribbed surface!

For this announcement of Knoll.com's
Web site launch, Eileen Boxer's choice of
materials was precise to her concept. "I want-
ed to represent a computer screen as closely
as possible," she says.

Lenticular printing can be done photo-
graphically or as an offset process in tiny
strips that are then covered with a plastic
coating called a lens that creates the 3-D
effect. Optical tricks require attention to
color, Boxer reminds us. "Certain colors
create good movement."

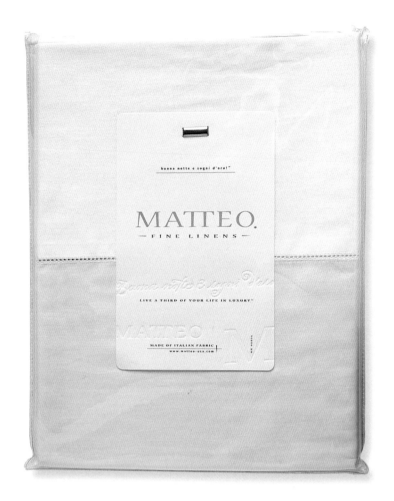

design firm
Margo Chase Design

client
Matteo Linen

materials
embossed cardstock,
metal grommet

Matteo Linen Insert

The luxury linen manufacturer Matteo had a budget problem that designer Margo Chase solved with an understated, elegant, and practical tactile design.

"Matteo makes very expensive products, and the problem was that because they're not doing large quantities, they couldn't justify having a different size insert for each product." Chase came up with the little silver metal stud, which she attached to the *outside*, to float the inserts inside packaging of any size.

"It solved the problem, and it also contributed to the feeling of luxury because it picks up on the silver foil in the printing, and because there's an actual object there."

Andromeda Brochure

Experimenting with materials can turn even the humblest product pitch into a commanding message. This is even true when the product is a not-so-humble twelve-million-dollar yacht from manufacturer Omega Marine.

To announce the launch of this champagne-and-caviar product, Maximo Escobedo of San Diego–based design firm Miriello Grafico, Inc. was asked to make a one thousand–run promotional piece.

"We wanted to make the brochure as much an experience as the boat," says Escobedo. "So we had the client make the stainless steel binder for us. It's based on a hinge and held together with three Chicago screws." The binder's burnished finish not only catches the light but also the eye. In the hand, it imparts the confidence of precision craftsmanship. "With this design, they had to go out on a limb, but once they saw that we knew what the boat was about and that what we were doing would give them an edge—they trusted us."

design firm
Miriello Grafico, Inc.

designer
Maximo Escobedo

client
Omega Marine

materials
stainless steel riveted
binder, textured paper

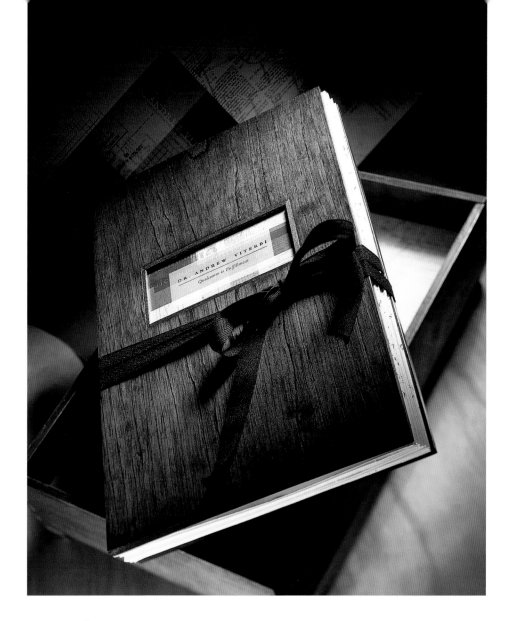

design firm
Miriello Grafico, Inc.

designer
Michelle Aranda

client
Qualcomm

materials
cherrywood cover, 23' (7m)
long accordion-fold paper,
glass inscription window

Dr. Viterbi Retirement Book

When a founder of the wireless communication technology corporation Qualcomm announced his retirement, it fell to Michelle Aranda of Miriello Grafico to design a keepsake that would convey the deep respect of his employees. Aranda's solution was a book with handmade cherrywood covers that folds out, accordion style, to over twenty feet. During production, the paper was printed with photos from the honoree's life and then shipped around the world to be signed by the company's eight thousand employees.

**"A plaque would have been too cold, too easy to forget about," says Aranda.
"We wanted to design something that Dr. Viterbi would keep out to look at and touch—something of substance, like a piece of furniture."**

Te'nere Expedition Announcement

Maps printed on silk were given to Allied pilots and paratroopers in World War II. Silk is light, strong, easily concealed, and the fine weave allows for graphic detail.

Rebeca Méndez designed this map on a silk scarf while planning her honeymoon expedition to Niger. Several family members and friends joined the expedition, and the scarf served as a bon voyage gift for all. The scarf is sprinkled with witty details, such as, "Adam & Rebeca's Honeymoon," and "Augustin's 45th Birthday." Single words describing extremes of human experience mark the degrees of longitude and latitude along the map's edge: Love, Limitlessness, Despair, etc.

design firm
Rebeca Méndez
Communication Design

manufacturer
Microsoie/Montreal

material
silk

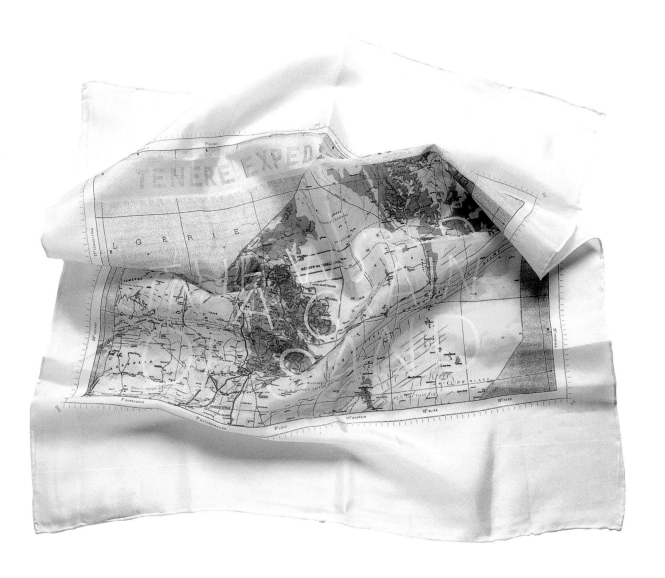

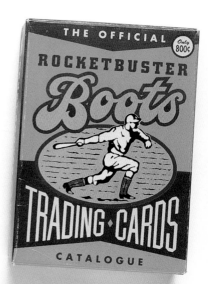

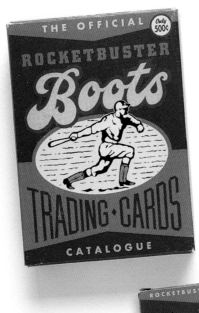

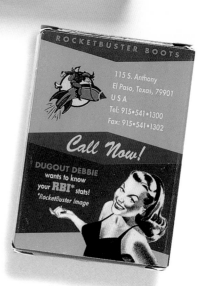

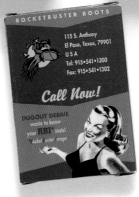

Trading Card/Sticker Catalogs

The folks at El Paso's Rocketbuster Boots don't drop names, but they could if they wanted: Mel, Sly, Billy Bob, Arnold, and Oprah all wear Rocketbuster's handmade western boots. Rocketbuster also holds the Guinness World's Record for Largest Cowboy Boot (almost five feet, or 1.5 meters, high). Nearly everything about this small craft-oriented manufacturer is remarkable, including their tactile catalogs.

Rocketbuster boots are not only collectable, but each pair has a unique thematic story to tell, and co-owner and in-house designer Nevena Christi realized that trading cards could perfectly embody the uniqueness and collectibility of the boots. "You have to make something that people are going to keep," she says, "Because there's just so much junk out there in the world." Christi adds that the catalogs themselves have become collectable, fetching $50 apiece on the on-line trading Web site ebay.com.

"The biggest challenge to making [the trading cards] was color correction, because people expect the product to look like it did in the catalog, and this was printing so many colors at once, and on cardboard, which we wanted to use because it will last," Christi says.

Although the playing card catalogs were instantly popular, retailers who circulated them amongst their customers found that cards were disappearing from the decks.

To address this, Christi did a run of trading-cards-as-stickers. Not surprisingly, the stickers were as popular as the cards had been. "But the stores can stick the stickers in a book to show people, so they won't get lost."

Explaining that both the boots and the catalogs were collated and packaged by hand, Christi laughs, "We do things the stupid way here." We should all be so stupid, however: Rocketbuster has a twelve-week waiting list for boots that cost as much as a new Vespa, and its catalogs are in demand even though they cost $12 retail. "If somebody buys a pair of boots, we give them the twelve bucks back," Christi adds.

design firm
Rocketbuster Boots
El Paso, Texas

designer
Nevena Christi

client
Rocketbuster Boots
self-promotion

materials
cardboard, stickers

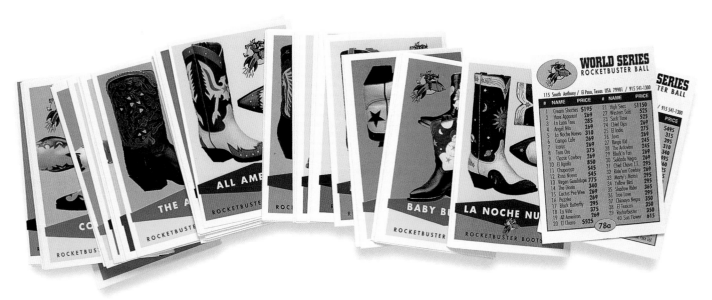

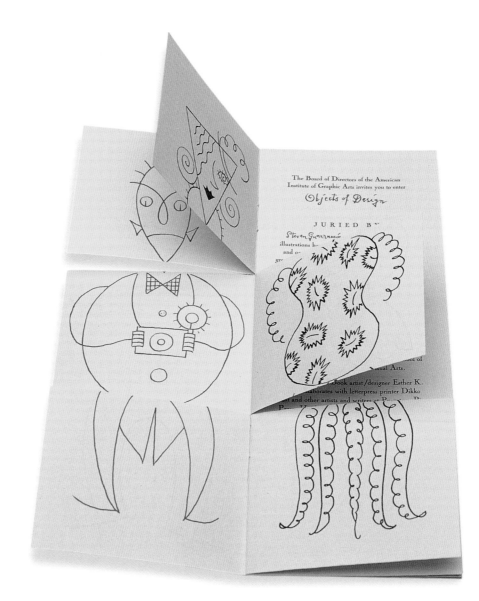

design firm
Studio Guarnaccia

designer
Steven Guarnaccia

client
AIGA: American Institute
of Graphic Arts

material
paper

AIGA Competition Brochure

Steven Guarnaccia designed this playful brochure to call for entries in an AIGA competition of small-run objects that didn't fit into any other design category. Since Guarnaccia's own multifaceted career keeps him in a similar uncategorizable category, it's no surprise that he was also the competition's chair.

"I'm interested in paper toys, and so I wanted to give the call for entries a sense of being an object, to move in your hands," he says.

Patrick Robinson Direct Mailer

Although its function was to announce Patrick Robinson's retail release, the real mission of this piece was to set itself apart from the sea of similar announcements flooding fashion retailers. "We came up with the proportion first," Jamie Oliveri explains, "But there were no envelopes that size, so we made one."

The announcement and the tactile envelope were a perfect match. "We liked the alarming contrast of the slick piece inside and the rough piece outside.

The label and postage areas had to be debossed so the label and stamps would stick."

design firm
Wen Oliveri

art direction/design
Jamie Oliveri,
Cinthia Wen

client
Patrick Robinson

materials
cardstock,
e-flute envelope

Designer Darby Scott goes out of her way to give real-world information to her tactile graphics students at the Cleveland Institute of Art. Staying in business, she explains, is often more about creating practical project budgets than developing amazing designs.

"One of the jobs that a designer has is creating financial feasibility," she says. "Frequently, if an idea can't be amortized with multiple uses, a client can't rationalize the expenditure. As a designer, it's your responsibility to turn an expense into an investment." She suggests consulting with clients concerning other uses for a design, for instance, letting a brochure double as a direct mail piece.

touch QUOTE

Scott also explains that part of creating manageable budgets is knowing everything you can about materials manufacturers. One way she stays up to date with industry professionals is by attending conferences of the Color Marketing Group. The CMG is a nonprofit association of color designers dedicated to enhancing the "function, saleability, and/or quality of a product through their knowledge and appropriate application of color." Scott says that she benefits from the organization's forecasts and recommendations as well as the many contacts she makes with unusual or hard-to-find vendors. For example, she might find out about an unexpected material or color used in car manufacture or fashion design that she could use to enhance a particular tactile project.

design firm
Unfoldz

designer
Darby Scott

client
Automated Packaging
Systems

materials
cardboard,
clock mechanism

Automated Packaging Systems Paper Clock Promotion

When designer Darby Scott begins work on a three-dimensional
paper design, she turns into a big kid. "Long before I jump on a computer,
I'm cutting and snipping in a very sophomoric way. I'm like a five-year-
old with a pair of scissors and white paper. You have to have the
confidence of a child. If you jump on your computer too early, you'll
lose all that for eternity."

For projects like this working cardboard clock for Automated
Packaging Systems—an international manufacturer of packaging
equipment and materials—Scott folded and pasted until she came up
with a usable pattern. She then took this elementary prototype to the
printer to begin feasibility discussions.

"Before I go to the client with the design," she says, **"I need to look at it from a
basic manufacturing vantage."** Scott, who teaches an introductory class in three
dimensional graphics at the Cleveland Institute of Art, adds that tactile projects
succeed or fail based on the relationships a designer has with her vendors.

**"There has to be a real air of cooperation between you and the manufacturer,
and a willingness to test on the press."**

Columbia TriStar Interactive Press Kit

 For some designers, tactile graphics is about interactivity and putting the product in a startling new context. That's all well and good of course, but sometimes experimenting with materials comes down to just plain *fun*.

 With this press kit for Columbia TriStar Interactive, the eye is first drawn to a bright plastic binder peeking out through the smoke-and-mirrors silk-screened polypropylene bag. Once the binder is reached, it reveals six whimsical dividers that have been printed, punched, perforated, and textured with a range of wonderfully wacky '50s-style children's games. These little marvels range from connect the dots to scratch and sniffs. A bright pair of plastic scissors is provided for paper doll cutouts.

"I like touching things," says designer Winnie Li. "I'm always looking for opportunities to challenge myself with a new material."

design firm
Winnie Li

designer
Winnie Li

creative direction
Wyndham Chow

photography
Benny Chan

client
Columbia TriStar
Interactive

materials
silk-screened polypropy-
lene binder, paper inserts,
plastic scissors

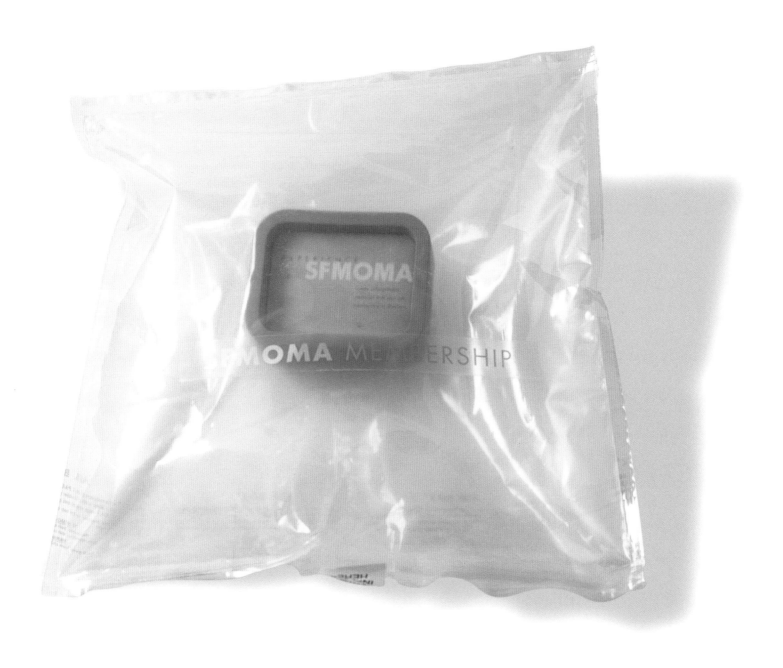

design firm
Anvil Graphic Design

art director
Laura Bauer

designer
Cathy Chin

concepting
Allan Ratliff

client
San Francisco Museum
of Modern Art

materials
foam picture
frame, Air Box

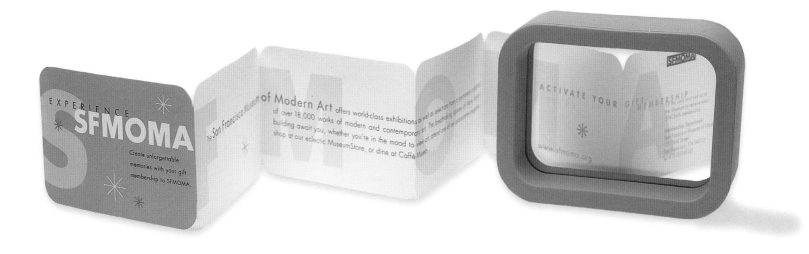

San Francisco Museum of Modern Art Membership

Anvil Graphic Design spent a lot of time in painstaking research for a high-tech client who needed packaging to ship fragile electronic parts. The designers were thrilled to discover these remarkable Air Boxes, but when the client finally opted for more conventional packaging, the Air Box found its way to Anvil's hold shelf. Not for long, however.

Preparing for a gift membership drive, fund-raisers for the San Francisco Museum of Modern Art approached Anvil to design a freebie that would accompany gift memberships. Two parameters: First, the free gift would be displayed in the museum lobby to advertise the gift membership drive, so the packaging needed to stand on its own as an object worthy of the surroundings; second, the budget was very limited.

"We know lots and lots of vendors, and one was willing to give us a discount on these great frames, so we decided on those first," says Laura Bauer, Anvil's creative director. "Museum literature had to go in the package, so we made a little fold-up piece and slipped it inside the frame."

The final question was how to package and display the frame. "We showed the Air Box to the client, and she just loved it, because it was so new, and also because they could display the whole thing, and it would look great," says Bauer. Best of all, there's no need for environmentally unfriendly packing peanuts as the work provides its own insulation.

Even in the shadow of the greatest artworks of modernity, this design is a standout for its stylistic simplicity and tactile charm.

design firm
Gumption Design

partner/creative director
Evelyn Lontok

client
Gumption Design
self-promotion

materials
compressed sponge

Spring Cleaning Self-Promotion

"I always wanted to do something about spring cleaning," enthuses designer Evelyn Lontok, but it wasn't until her mother returned from a trade-show with several compressed sponge give-aways that she came up with this zany but useful self-promo. "I do a lot of work with a letter press that is willing to run absolutely any material as a test. I brought in an 8.5" x 11" (22 cm x 28 cm) sheet of compressed sponge and it totally worked." The result is a perky useable that invites customers to "get started with brilliant designs." Lontok's fun design got her lots of notice. (And her letterpress vendor is still using the sponge leftovers to clean up around the shop!)

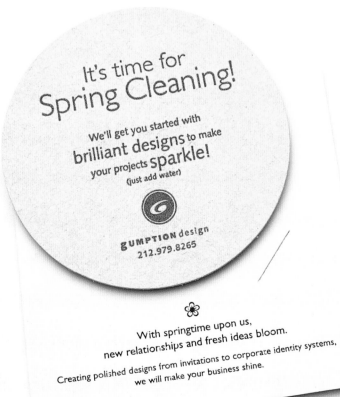

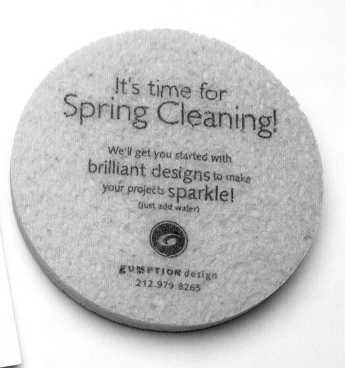

design firm
The Riordon Design
Group, Inc.

designer
Blake Morrow

photography
Blake Morrow

client
Riordon Design Group,
Inc. self-promotion

materials
heavy board, Naugahyde,
paper

RDG Mondo Self-Promotion Mailer

Every now and again it's nice to reintroduce yourself to a regular client, Ric Riordon believes. "When you get working with a certain market you tend to get type-cast," he says. "We do a lot of packaging in Nashville and Los Angeles, polished stuff. We wanted to show something a little different, something less formal and more playful." Nothing shakes up expectations like a tactile presentation, evidenced by this understated, yet off-center, leave-behind.

There is a nice contrast between the stiff paper covers and the (orange!) Naugahyde, juxtaposed with the deep-embossed silver stamp that emulates the wire binding. The pages inside are the size of CD jewel cases.

The piece expresses sophistication yet embraces the Gen-X spirit of the projects Riordon was targeting. "We had a great response, and it got us the jobs we wanted," he says.

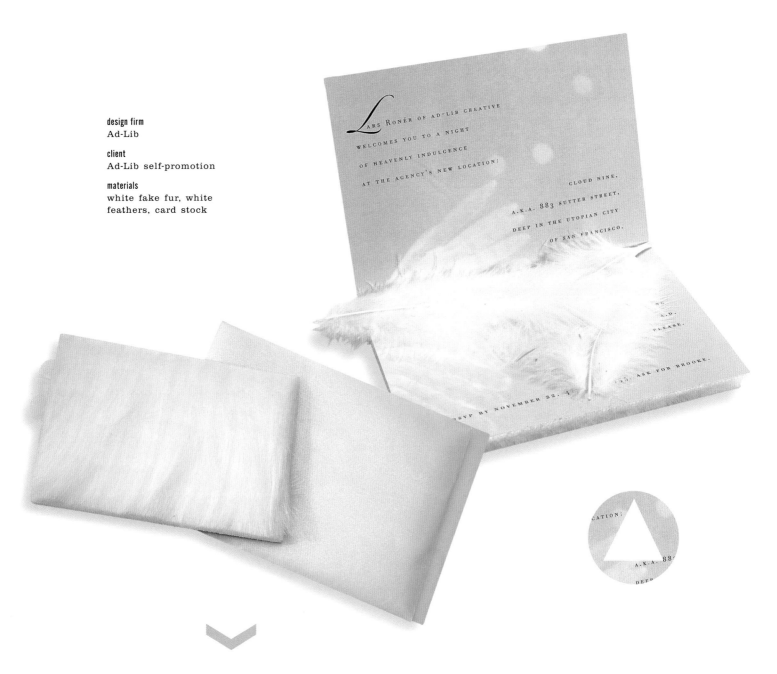

design firm
Ad-Lib

client
Ad-Lib self-promotion

materials
white fake fur, white
feathers, card stock

Heavenly Invitation

As Amanda DeHaan of San Francisco's Francisco's Ad-Lib Creative describes it, this piece was designed to "stand out from the glut of invites" that abound during the holiday season. The firm's creative team designed this heavenly invitation to express the angelic treatment they could expect at the party.

The artists had a lot of fun deciding on the perfect material for the outside of the card. Originally they envisioned cotton batting for a white cloud look, but found it wasn"t lush enough. Ultimately they bought white fake fur, which they hand-cut, trimmed and mounted onto the cards. To highlight the beatific feathered wing design inside, the team—which included art director Ksenya Faenova and designer Steven Wasden—added several loose white feathers.

"The party went really well," adds DeHaan. "We had a harpist, and manicurists and a masseuse. We projected *It's A Wonderful Life* on a wall and only served desserts because, of course, there's no real food in heaven."

Fame Self-Promotion

Admit it: the The first time you saw that yellow plastic caution tape on the street, you couldn't couldn't help wondering what it would be like to rip through it. For this marketing piece, the Fame retail branding group decided to invite potential clients to have a go. "What we create needs to do more than simply get the message out there," says designer Stuawart Flake, "It needs to shout the message louder, or be more clever some-how. Communication should have some power behind it." This oversized piece shipped in a silver acetate anti-static bag, but it was its tactile nature that lent impact. "In retail," says Flake, "Scale and excitement mean everything."

design firm
Fame

creative director
Tina Wilcox

client
Fame self-promotion

materials
paper, coverstock,
caution tape,
anti-static bag

THIS PACKAGE CONTAINS POWER.

FAME

CAUTION

IT'S THE POWER OF A BRAND DONE RIGHT.

Retail Promotion

Interactive Media

Retail Advertising (Television, Radio, Print, Outdoor)

Public Relations

Media Planning

Retail Brain Trust

Case Study No. 011 Software Etc

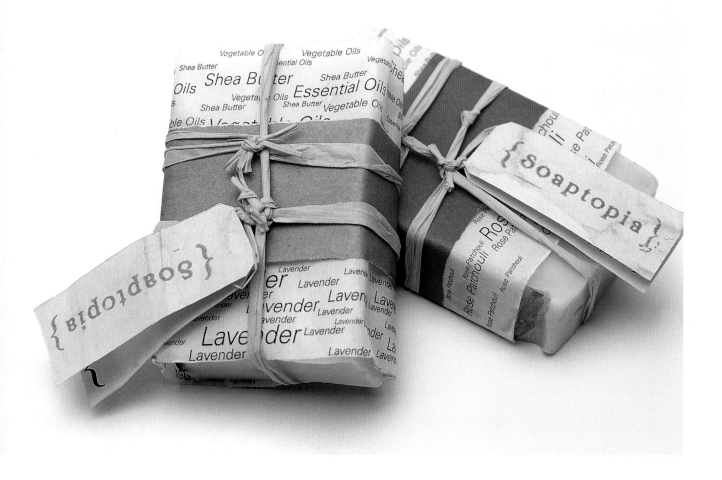

Soaptopia Packaging

When the 44 Phases designers saw the soap in Soaptopia's new line of bath products, it was clear to them that its sensuous handcrafted feel called for a tactile solution, rather than a traditional 2-D graphic. "We wanted the buyer to pick it up and experience the feel of it right there in the store," Tsai says.

The minimalist design keeps the soap's best features forward, including its subtle scents and pale colors reminiscent of Asian pottery. The raffia ribbon emphasizes the artisanal, East-meets-West spirit of the Soaptopia line.

design firm
44 Phases

designers
Marco Pinsker, Daniel H. Tsai, Luis Jaime, Julio Ferrario, Frances Torres, Chalalai Haema

creative director
Daniel Tsai

materials
soap, raffia, label

Shady Brook Farms Dial-a-Chef Press Kit

Designer Evelyn Lontok loves re-discovering common objects and incorporating them into her work. For client Shady Brook Farms, an all-natural turkey product provider, Lontok came up with two lip-smacking marketing campaigns to announceing the company's complementary "Dial-A-Chef" hotline program.

Targeting magazine editors, the campaign featured laminated placemats inside a media kit that opens like a menu. Lontok got the idea after watching a friend's child learning geography from an instructional placemat. For the company's summer grilling campaign, she printed recipes on doggie bags. "It was really flukey how I came up with that one," she adds. "I had ordered some Chinese food and some ribs had come in one of those bags." Lontok simply followed the number she found in fine print on the back of the bag to reach the container manufacturer and make her order.

design firm
Gumption Design

partner/creative director
Evelyn Lontok

client
Hill and Knowlton
Public Relations

materials
insulated doggie bags,
laminated card stock

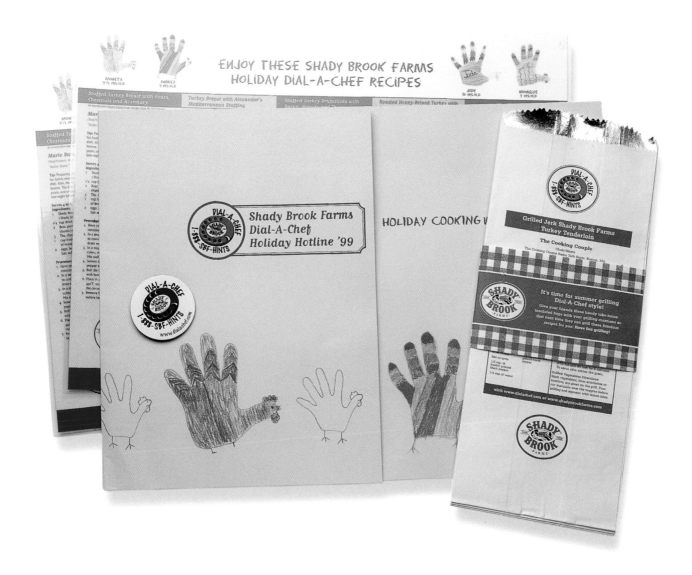

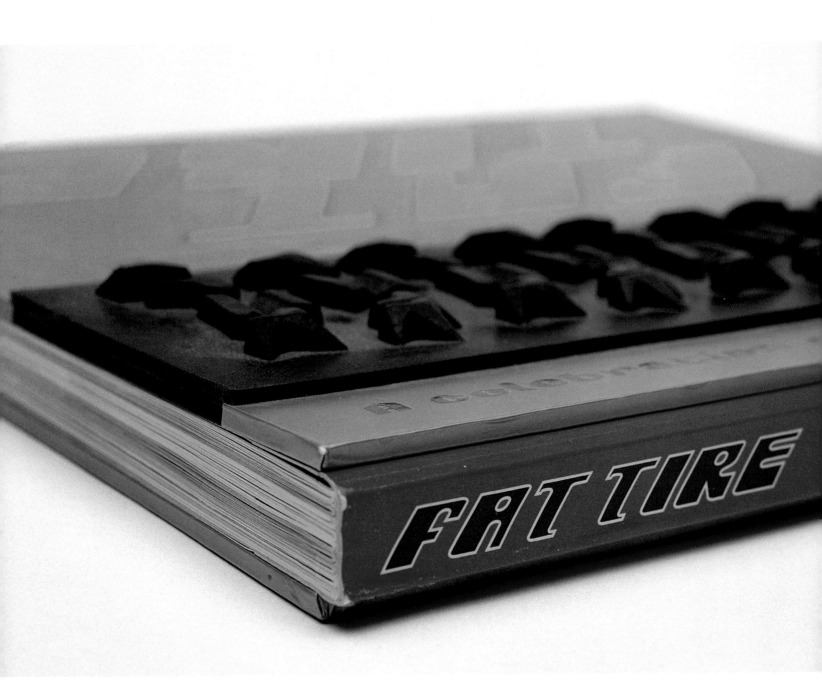

You can't tell a book by its cover, unless that cover happens to be tactile. Tactile design allows content to reach beyond a publication's pages, turning an ordinary book into an object to be reckoned with. Yet, few areas of publication design require so much foresight as books with a tactile dimension. Book designers considering touch solutions have to think not only of the challenges of manufacture but also the hazards of shipping and even display strategies. How to produce the design in quantity? Can it be shipped safely and inexpensively? Can it be displayed on a retail shelf? During each step of the process, the designers featured here worked closely with their vendors to create designs so enticing that retailers have in some cases pushed books with 2-D covers aside in order to make room for the table-top display of these tactile delights.

COVERING BOOKS

design firm
Wen Oliveri

art direction/design
Jamie Oliveri,
Cinthia Wen

client
Patrick Robinson

materials
leather, metallic paint,
silk ribbon, paper,
cover stock,
bookbinding tape

Patrick Robinson Brand-Positioning Book

When fashion designer Patrick Robinson left Armani to start his own brand, he came to Wen Oliveri for graphics that would manifest his strong personal ethic and design aesthetic. To hear Jamie Oliveri describe it, the lyrical nature of this brand positioning piece was a designer's dream.

"It was so nice not to have to distill it down like we would with a corporate project," Oliveri sighs. "We had the luxury of doing tons of research and then just collapsing it all into a book."

Although the designers were free to be wildly expressive, they nonetheless kept a disciplined, restrained hand. Dipping only occasionally into the tactile palette, each time they did it was to startling effect.

Oliveri relates, "We noticed similarities between the photo of the leaf and the leather that Patrick was using in the collection, so we included bits of the leather. Suddenly, the tactile embellishment brought the photo to life. Also, that little hand-stroke of metallic paint works off the black-and-white shot of the ocean and animates it."

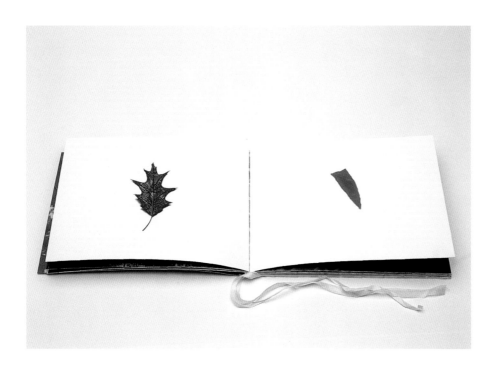

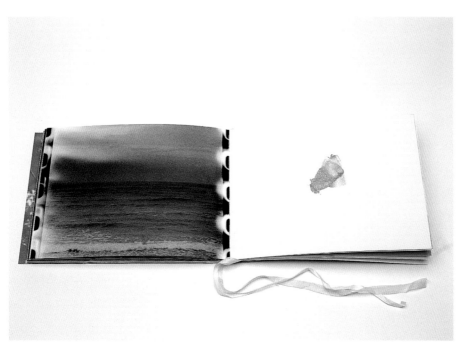

"Patrick's all about not judging a book by its cover," Oliveri says, "So the cover is left unattached, with this beautiful spine exposed." The extra long ribbon is the same fabric as the binding material. The project had a small print run, and handwork gave it a wonderful personalized feel.

"The biggest challenge was the binding," Oliveri says, "Because it had no outside support. It was a labor-intensive project, but it was a labor of love."

design firm
Boxer Design

designer
Eileen Boxer

client
Tate Gallery

materials
book, synthetic fur

Book Prototype, *Desire Unbound*

Planning a major show to survey the erotic spirit in art's Surrealist movement, the Tate Gallery in London also wanted a volume to accompany the exhibit. For this they contacted New York designer Eileen Boxer.

"It was a challenge," Boxer says. "[The show] represents a wide range of artists from the movement, and I didn't want to represent one artist over the others on the cover." Boxer solved the problem with a tactile graphic that embraces the sensuality of the exhibition's theme, *Desire Unbound*, while embodying the outrageous vitality that was a Surrealist hallmark. Although the piece doesn't single out one artist, the design is nonetheless a subtle nod to Surrealist Meret Oppenheim's classic sculpture, *Le Dejeuner en Fourrure*, a fur-lined tea cup.

After deciding on the fur, Boxer next turned to color. "The Surrealists used pink a lot, but I wanted one that's slightly dirty-looking, slightly off-pink. They weren't about pretty; their things always made you slightly uncomfortable, and so this combination of the sensuous fur and the pink is slightly 'off.'"

Kids love to interact with books and are always ready to succumb to tactile appeal. Fingerprints, food stains, and the occasional tooth mark are badges of honor on children's books. Grownups like to play with their books, too, although they acknowledge it less frequently, and tend to call it aesthetics.

The tactility of books is undeniable: A book lives simultaneously in the readers' hands and gaze, and a well-designed book delivers information to both the fingertip and the eye, as these examples from San Francisco's Chronicle Books illustrate.

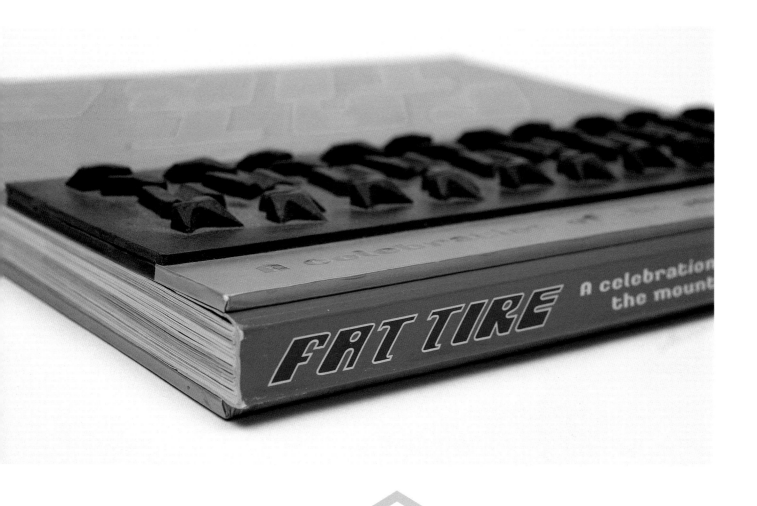

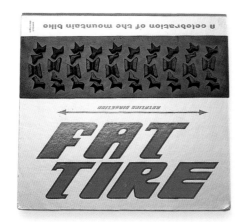

Fat Tire
Amici Design, Joe Breeze

Although many books about how and where to ride mountain bikes have appeared over the years, this was the first to simply celebrate the sport and its daredevil spirit. "We didn't want the cover to be just another picture of some guy flying down a trail," says Michael Carabetta, creative director of Chronicle Books. "We wanted something that was unique, an object as much as a book."

Rather than fully covering the book block, the cover board was glued directly onto the endpapers, but it stopped short of the spine, to differentiate it from other books on the shelf. When displayed flat on a countertop or table (which is most often the case with this book, Carabetta says), the most striking element is the big beautiful strip of knobby tire tread.

design
Amici Design

client
Chronicle Books

material
heavy board, tire tread

"We tried cutting up tires and gluing them on, but it didn't work, so we had the strip manufactured in Asia, and we finally found the right cement to attach it, which the printer did for us. To ship it, we had to use the back-to-back, belly-to-belly method and they stacked quite neatly."

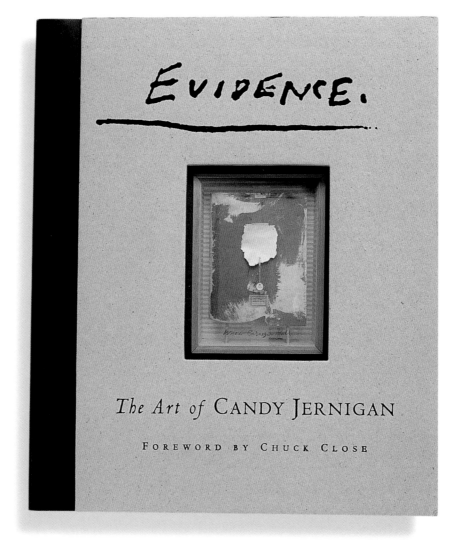

EVIDENCE.

The Art of CANDY JERNIGAN

FOREWORD BY CHUCK CLOSE

book and cover design
Laurie Dolphin,
Yusuf Sayman

design consultant
Frank Olinsky

photography
John Bigelow Taylor

client
Chronicle Books

material
die-cut cardboard

Evidence, The Art of Candy Jernigan
©Laurie Dolphin

The cover of a fine-art retrospective is a tricky thing, says Chronicle's creative director Michael Carabetta. "You can tip a photo of one of the artworks onto the cover, but that can be too straitlaced. A lot of Candy Jernigan's artwork is handwrought, one-of-a-kind collages and paintings, and we needed to reflect that."

This cover captures the authenticity and unpretentiousness of Jernigan's work by simply getting out of the way: Undersized bare cardboard covers suggest a file box of police evidence, while the exposed slick black spine hints at the careful thought underpinning Jernigan's found objects and seeming slapdash constructions.

Revealing the color image through a die-cut frame brings us immediately into the artist's multilayered vision.

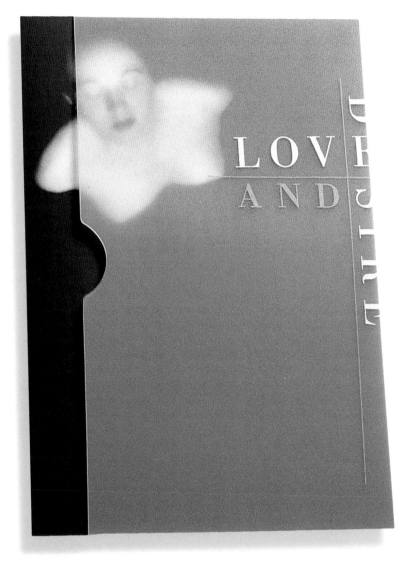

cover design
Concrete, Chicago

client
Chronicle Books

materials
translucent plastic, paper

Love and Desire
by William A. Ewing

Although photography can portray passion, a tactile graphic can directly suggest the feel of the experience. The rich black of the front and back cover photos on this "visual survey of human passion" are both obscured and revealed by the soft, skin-toned translucent slipcover. "In feel, the cover is as close to human skin as you can get, but it's also sheer like a garment that leaves something to the imagination," says Michael Carabetta, creative director of Chronicle Books.

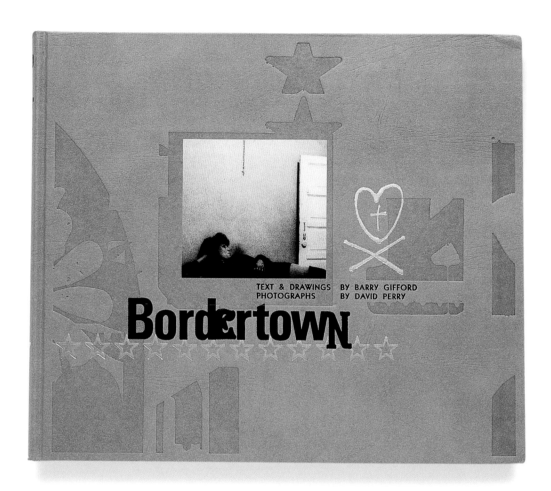

designer
Martin Venesky

design assistant
Geoff Kaplan

client
Chronicle Books

material
embossed label material

Bordertown
by Barry Gifford, David Perry

Bordertown paints a stark portrait of life along
the U.S.-Mexican border, with brooding black-and-white
photography by David Perry and text by one of filmmaker
David Lynch's longtime collaborators, maverick writer
Barry Gifford. The desperate, dispossessed spirit of
bordertown life is conveyed by the blind-embossed and
foil-stamped cover, made from the same material as blue
jeans waistband labels.

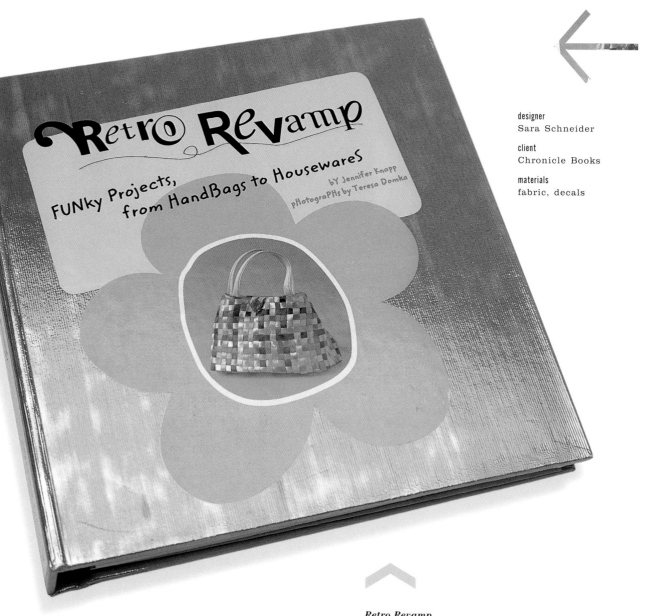

designer
Sara Schneider

client
Chronicle Books

materials
fabric, decals

Retro Revamp
by Jennifer Knapp

"The concept of this book is using leftover materials that don't have a purpose anymore to make things that are fun and unique," says designer Sara Schneider. "I went to a lot of different fabric stores and vintage shops and toy shops, and found this green shimmery fabric on a mermaid doll."

Adhering graphics to the mermaid fabric turned out to be a bit of a challenge, until Schneider realized that decals would convey not only the '60s spirit of the book but also a gleeful, tactile dimension.

Gumby's Colors
Holly Harman
©2000 Chronicle Books

"The EVA foam for these covers is a wonderful, nontoxic material that gets mixed up like cake batter; you can make it into anything you want," says Kristine Brogno, manager of children's design at Chronicle. Incorporating an actual figurine into the book was the designers' first decision, because, "You gotta have something to play with."

Although inexpensive and easy to mold, the EVA foam has its trade-offs: It's a tricky surface for four-color printing, so the covers had to be screen-printed, which means less control. Also, the figures are duplicated in 2-D on the cover under the foam, and getting the registration right required eagle-eyed supervision.

The figurines have wire armatures sandwiched between two layers of foam and are—á la the original Gumby and Pokey—wonderfully bendable.

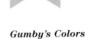

Pokey Counts
Holly Harman
©2000 Chronicle Books

Bendable
Pokey
pops out!

designer
Michael Mabry

art director
Kristine Brogno

client
Chronicle Books

materials
EVA foam, heavy board

Night Writing: A Journal
©2001 Robie Rogge

In the nineteenth century, the French military used a type of code called Night Writing, which ultimately formed the basis of the Braille alphabet. The term night writing also suggests dream notation, which is decryption of another sort. Designer Alethea Morrison brought these two ideas together in a powerful tactile design for the Chronicle Books Gift Division.

Braille letters are embossed on each of the divider pages, suggesting secrets and the linguistics of the unconscious. Morrison chose the editorial content and graced each divider with a bit of typographic cryptography abstracted from one word of that divider's quote. The padded midnight blue felt fairly whispers of mystery and hidden oracles.

"Night hath a thousand eyes," wrote John Lyly in 1600. Unfortunately, we don't know if Lyly had a dream journal as exquisite as this. (But we're pretty sure he didn't have the neat-o light-up ballpoint pen that comes with this tactile treasure.

designer
Alethea Morrison

client
Chronicle Books

materials
felt cover, embossed cover-stock dividers, pen

design firm
Kelly Tokerud Design

art director
Kristen Nobles

client
Chronicle Books

produced by
Swans Island Books

material
Beluga textured binding

The Truth about Great White Sharks
Mary M. Cerullo
©2000 Chronicle Books

Good photos of Great Whites are hard to come by. Although books about sharks generally sell well, the inaccessibility of the models (and their double rows of sharp teeth) mean that the selection of shark photos is limited. One way to set your shark book apart from the competition, however, is with tactile design.

"We very much wanted the cover to feel as close as possible to shark skin," says Kristine Brogno, describing Chronicle's use of the high-touch Beluga surface from Rexam. "It makes the book stand out in the marketplace, and for older kids, the tactile quality adds to the perceived value of the book."

Superman Address Book
©1999 DC Comics

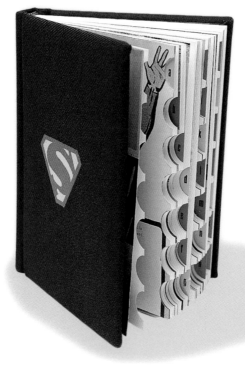

designers
Chip Kidd,
Chin-Yee Lai

cover designer
Henry Quiroga

photography
Geoff Spear

client
Chronicle Books

material
plastic

Catwoman Address Book
©2001 DC Comics

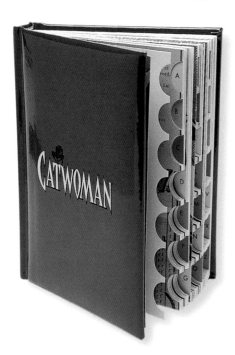

designers
Chip Kidd,
Chin-Yee Lai

photography
Geoff Spear

client
Chronicle Books

material
lycra

Batman Address Book
©2001 DC Comics

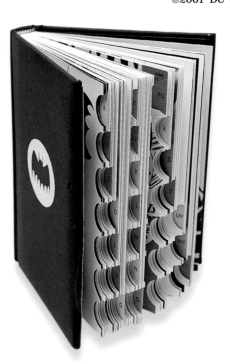

designers
Chip Kidd,
Chin-Yee Lai

cover designer
Henry Quiroga

photography
Geoff Spear

client
Chronicle Books

material
EVA foam

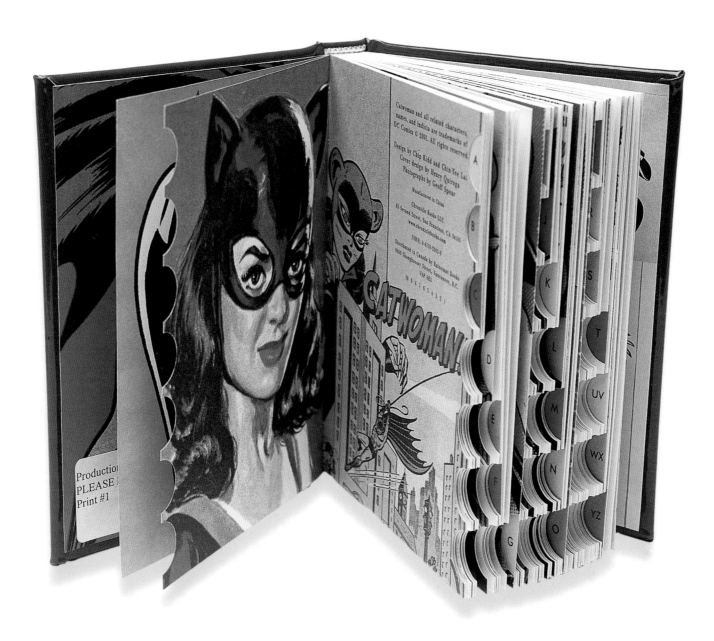

Design by Chip Kidd and Chin-Yee Lai
Cover design by Henry Quiroga
Photographs by Geoff Spear

Manufactured in China

Chronicle Books LLC
85 Second Street, San Francisco, CA 94105
www.chroniclebooks.com

ISBN: 0-8118-2963-0

Distributed in Canada by Raincoast Books
9050 Shaughnessy Street, Vancouver, B.C.
V6P 6E5

10 9 8 7 6 5 4 3 2 1

Production
PLEASE
Print #1

Even superheroes need to keep track of addresses and phone numbers, and Superman was the first crime-fighter to be honored with an address book from Chronicle. The padded cover and Lycra fabric were designed to emulate the Man of Steel's chest and famous blue union suit.

Not to be outdone, Batman and Catwoman both got address books to match their outfits. Catwoman's book is squeezed into the high-gloss plastic that she favors, and Batman's positively broods in matte black rubber.

These little charmers are the perfect size to toss in a backpack, and the quirky materials and prominent logos will always earn a smile. The designers won't say if the books are actually bulletproof or not.

Wegman Baby Book
©1999 by William Wegman

"There's a kind of neutrality you have to be sensitive to with baby books," says Debra Lande of Chronicle Books Gift Division. "You have to be gender-neutral, so the Wegman dog's color was perfect. The cover also feels soft like doggy fur, which is also like newborn babies."

design firm
Empire Design Studio,
NYC

client
Chronicle Books

material
felt cover

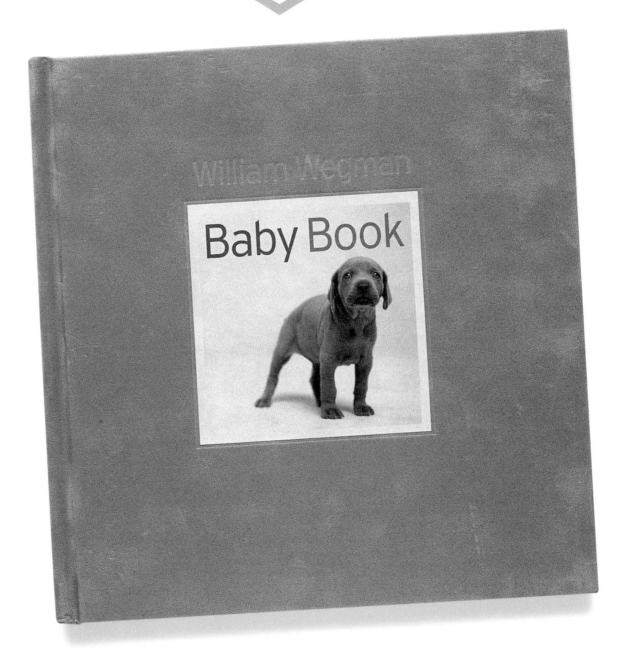

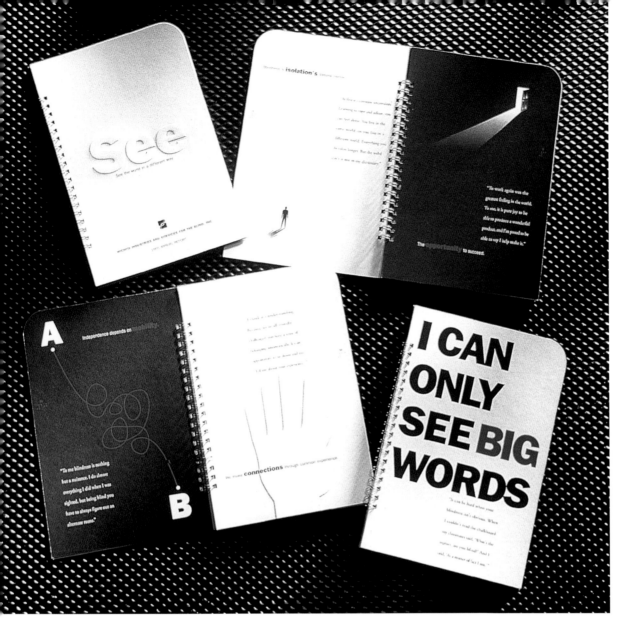

Envision Annual Report

Envision is a nonprofit organization dedicated to helping the blind. Commissioning an annual report design, Envision told The Greteman Group that they wanted readers of the annual to be able to imagine the feelings of a blind person. With this mission in mind, Sonia Greteman took quotes from Envision's blind clients and turned them into these touching, touchable graphics.

Throughout the books, die cuts convey the perspectives of the sightless world. A die-cut door, for instance, portrays the isolation that the blind often feel. "Then they discover an organization like Envision, and the little door opens and light shines in," says Greteman. Conversely, the embossing suggests the blind's extraordinary "reliance upon touch."

design firm
The Greteman Group

design/art direction
James Strange,
Sonia Greteman

client
Envision

materials
embossed, die-cut paper

black bread 5

spring 97 unit price 5.00

Black Bread Poetry Anthology

Jason Ring learned a lot from skateboarding. "When I was a teenager, skateboarding was the only mode of transportation I could find that could be experimental and creative. It's a linear process that gets you from point A to point B, but along the way you also have the opportunity to do something spontaneous and exciting." For Ring, design is similar: creating within a framework, but jazzing along the way.

Ring's approach—and his sense of humor—are witnessed in this wacky and endearing presentation of editor Sianne Ngai's *Black Bread Poetry Anthology*. "Sianne left it up to me to come up with a reason for the name of the anthology. I mean, why is it called *Black Bread*? So I thought maybe the book is a loaf of bread and each page is a slice. So I scanned individual slices of Wonder Bread and placed those images on different pages. Then I thought, let's take it to another level and put end-pieces of bread on the front and back cover. Then I thought, how could I take this further still? So I put it in a Ziplock sandwich bag."

The limited run of less than five hundred was offset printed and then hand-bound by Ring.

design and binding
Jason Ring

client
Editor, Sianne Ngai

materials
paper, sandwich bag

"The whole thing about living is experiencing. How do we experience? First and foremost through our senses. If you can combine more than one sense in a design, more than the visual, specifically including the sense of touch, then you double the experience. And if the two parts, the visual and the tactile, work together to reinforce the whole, then you've got something really special. A rare treat."

WHAT DO
FIVE BILLION
ELECTRONICS CONSUMERS
WANT?

Cadence 1997 Annual Report

design firm
Oh Boy, A Design
Company

designers
David Salanitro,
Ted Bluey

art direction
David Salanitro

photography
Ty Allison,
Russell Monk

illustration
Ted Bluey

client
Cadence

materials
mirrored cover stock,
paper

1997 Cadence Annual Report

"Deep tech" companies make the technology that makes technology
work, and they often go unknown to the average consumer. In the case
of this client, the tech was so deep that even the company's company's
stockholders were scratching their heads over just exactly what the
company did.

"It can be a bit confusing, unless you're you're familiar with technol-
ogy, and this helped clarify their position,"says Ted Bluey of Oh Boy,
A Design Company. Focusing on the "consumerization of electronics,"
Oh Boy used mirrored stock from Zanders to create an immaculate,
monolithic surface that asks the ultimate consumer question, "What do
you want?" The user's user's fingerprints and everyday wear-and-tear on
the cover leave an individualized, symbolic answer.

design firm
Oh Boy, A Design
Company

designers
David Salanitro,
Ted Bluey

art direction
David Salanitro

photography
James Stillings
illustration
Ted Bluey

client
Cadence

materials
cover stock, paper,
scratch-off panels

1998 Cadence Annual Report

"Deep tech" is technology embedded invisibily in consumer products,
like microchips in clocks, toasters, and coffee cups. ("Your coffee is get-
ting cold, sir.") Beneath the cover scratch-off panel on Cadence's 1998
annual report is the word Idea, and the scratch-off panels on the inside
photos each contain an idea for a deep tech consumer application (e.g.,
sun-sensing blinds).

idea

revenue in millions

$0.16	'96	$0.65*
$0.14		

earnings per share and earnings before goodwill*

you'
be

*Note
Earnings before goodwill excludes unusual items,
amortization of acquired intangibles, and the
effects of IMS.

1998 Cadence Annual Report [continued]

Finding a vendor to make the little scratch-off was tricky, and print-ing on top of the panels was even harder. "The scratch-off material is wax, not ink," says Ted Bluey. "It's not fine resolution, so we had to search for a creative way to do that. Williamson Printing in Texas is one of the few printers who have the patent on the process for printing on top of scratch-off's." All the effort was worth it, though.

"We got letters from shareholders saying, 'I finally understand what this company does,'" Bluey reports. Through tactility, these clever graph-ics got shareholders involved in the company's mission.

Conservatively, let's suppose that the imaginative electronic features embedded in this next generation of products allow manufacturers to sell each one of those new things for just an additional 10 cents. Now think about this. Based on our example, that's a $50 billion incremental market.

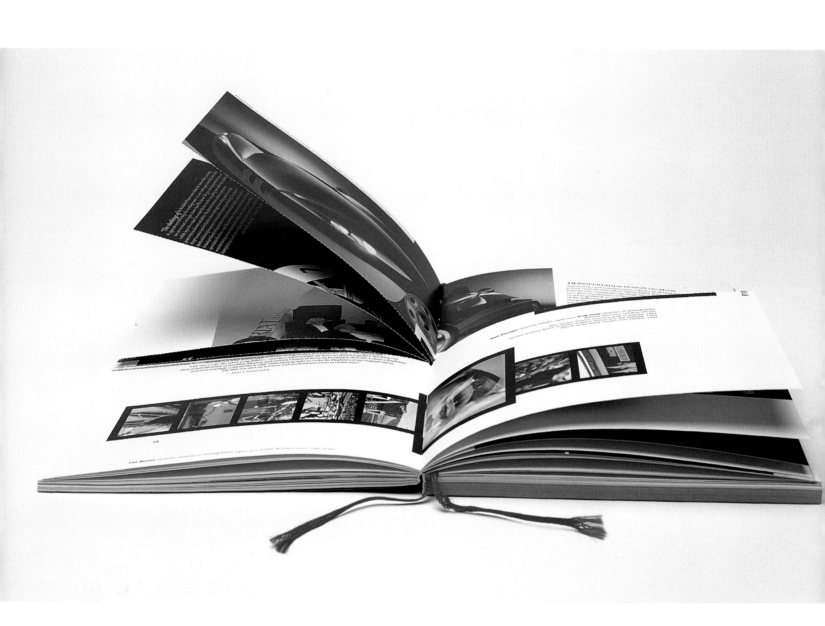

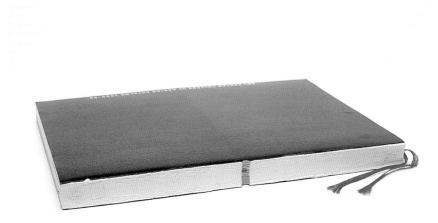

design firm
Art Center College of Design,
Design Office

design director
Rebeca Méndez

design assistant
Darin Beaman

client
Art Center College of Design

materials
perforated paper
and cardstock, silk ribbon

Art Center College of Design Catalog 1995/96

The impact of new media and technology hit Art Center College of Design in 1993 just as their new catalog was being conceived. "We had to consider that this might be our last printed catalog. This sense of ambivalence...became the vision," says designer Rebeca Méndez. Because the catalog was a tactile embodiment of that ambivalence, the reader's fingers explored questions that only the future could answer.

Opening the catalog, the reader is confronted with a rupture of classical book design. Both covers and all of the pages are horizontally perforated from end to end. Unbroken, the ominous perforations suggest a threat running through image and text, and when the pages inevitably separate, information splits and folds into sudden, unlikely combinations. These breaches and reconfigurations suggest the threshold on which design education stood in 1993, as well as the interdisciplinary mission of Art Center. Similarly, certain portions of the text are blurred or completely obscured.

Slyly, the outside of the design first suggests a rather dull, perfect-bound academic publication missing its cover. The exposed spine's thick ribbon of glue is interrupted by a small fissure revealing a strata of pages and a bright red silk bookmark. (Interestingly, the notch also suggests Art Center's most prominent architectural feature: The main building is a suspension bridge spanning a deep arroyo.)

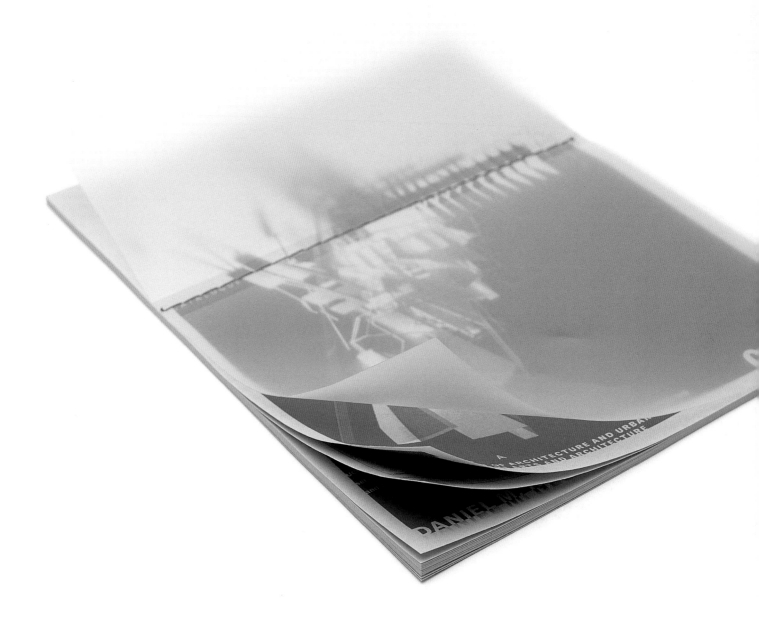

UCLA Department of Architecture and Urban Design Catalog 2000–2001

Each page of this catalog for the UCLA Department of Architecture and Urban Design is laid out with imagery on the left and text on the right. These two interconnected bodies of information are kept separate, however, by the unconventional stitched binding.

Because the catalog's information can only be unified in the eye—and hand—of the user, the separation encourages tactile interplay.

design firm
Rebeca Méndez
Communication Design

designer
Rebeca Méndez

assistant designer
Carolina Trigo

client
UCLA Department
of Architecture and
Urban Design

materials
paper, stitched binding,
translucent plastic cover

design firm
Rebeca Méndez
Communication Design

client
Slowpace

materials
paper, cover stock, heat-sensitive material

***Slowspace* Book Prototype**

Entitled Slowspace, this collection of essays by architects and artists explores the mercurial theme of "matter as a delay," says Rebeca Méndez. "The essays speculate on how to see time in materials, and how matter responds in time. The materials for the book itself were so important." Méndez's tactile cover is made from a heat-sensitive material that puts the book's theme right into the user's hand.

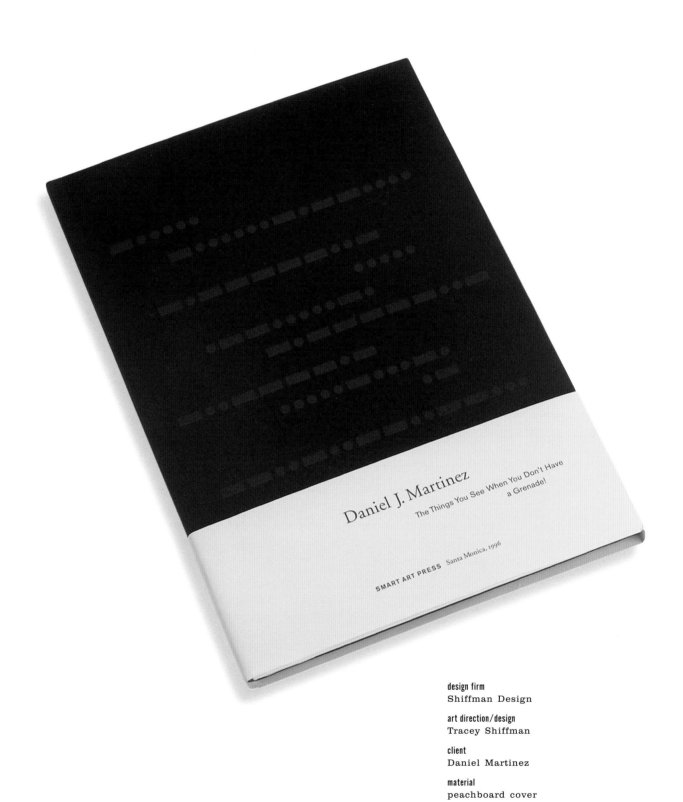

Daniel J. Martinez
The Things You See When You Don't Have
a Grenade!

SMART ART PRESS Santa Monica, 1996

design firm
Shiffman Design

art direction/design
Tracey Shiffman

client
Daniel Martinez

material
peachboard cover

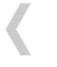

Daniel J. Martinez...Grenade!

"This was a book about the work of a very talented conceptual artist, Daniel Martinez. He brought the project to me, and he was willing to let me guide that journey," says designer Tracey Shiffman.

"A lot of the intrigue in Martinez's work is that his messages are coded. I chose the Morse code to describe that symbolically."

She adds, "I like the fact that the peachboard fur picks up actual lint. At first, the surface is pure and sexy, but the minute you run up against it you wish you hadn't. That's similar to the reaction people have with [Martinez's] work."

Sensable Technologies' Freeform™ haptic design interface allows users to carve virtual clay.

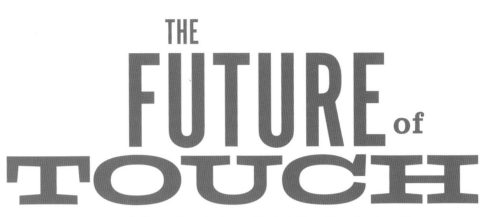

THE FUTURE of TOUCH

In the previous chapters we illustrated how dimensional graphics engage the mind and emotions through the added dimension of tactility. In this chapter we describe how haptics, the science surrounding the sense of touch, could affect the future of design.

The Power of Touch

Haptics represents the next logical evolution of our digital displays, explains interface designer S. Joy Mountford. "Everybody talks about multimedia, but the display of information isn't multimodal; you feel virtually nothing in the computer that you use today. But we are multimodal systems, so it's a question of how to make the most use of multimodal feedback," she says. "How do you get people who are seeing multimedia to feel multimodally?"

Although it might sound like haptic feedback could simply be the next nifty peripheral—making gameplayers' joysticks pull and shake as they would in a real dogfight, etc.—that estimation misses some important points: Haptics could allow us to trace a finger along the lines of a new car in a digital dealership or feel the suppleness of a fine leather jacket in an on-line catalog. Haptics will also let us "feel" 2-D graphics, which starts a whole new ball game for designers. Finally, haptics bears profound implications for the future of designed culture in general.

Tactile artist Rosalyn Driscoll recently began a collaboration with MIT's Touch Lab on a fine art/haptics project to explore the boundaries of haptic aesthetics. Driscoll describes the power of haptics this way: "If you're touching something, you have internal sensations that give you a subjective dimension, a sensory experience inside the body. If you're only looking at something, you're not aware of that sensation, but if you pick up an apple, you meet the flesh of the apple with your own flesh, and that feedback literally creates a sense of yourself." As haptics interfaces

become more sophisticated, the emotional impact of digital information will increase. When you touch a digital apple, it will touch you right back.

Another profound implication of haptics is that when a digital interface includes touch, the technology learning curve may be reduced, because with touch we *respond* to a stimulus with the same tool (the hand) that we use to *receive* it, creating an instantaneous interchange of information, as in the case of a car steering wheel. "Haptics is both a display and a control technology, both input and output," explains University of British Columbia haptics researcher Karon Maclean. "With haptic display you can both perceive and manipulate at the same time, and it's the only sense that you can do that with. It means you can react very quickly."

Dr. Mandayam A. Srinivasan, founder of MIT's Touch Lab, says that human beings are simply built to absorb certain types of information more easily through the sense of touch. "By channeling complicated data through touch it may be possible to have a more efficient transfer of information to the brain," he says. "In the same way that we now transform large tables of numbers into a graph, which is a more efficient way to deliver information about trends in the data."

Practical Haptics

It isn't hard to imagine the first effects of haptics on designers, once this technology enters the consumer arena. Browsing through an on-line clothes catalog, shoppers could not only *see* products, but scratch the woolies and tickle the silks as well, at which point haptics will join visuals as a tool on the designer's palette. Haptics will also simplify the designer's life by abbreviating time and distance, in that haptic samples of any material could be ordered from on-line vendors, for instance. Also, haptics is a two-way street that will not only replicate what you touch, but how you touch it: Through a haptics/robotics interface, you could fold an origami crane in Tokyo from your office in Cincinnati.

But these are only the most literal applications of haptics, and design is an interpretive craft, not a literal one. When the digital landscape is feel-able, designers will be able to experiment with entirely new harmonies and dissonances, ironies and surprises in the abstract interplay between visual, aural, and haptic information.

One Example (and Only One)

Like so much of technology, haptics engineering lags somewhat behind its vision, and there's lots of nuts-and-bolts work to be done before this technology becomes ubiquitous. Only one commercially available haptic product has been successfully marketed so far, Sensable Technologies' Freeform™ industrial-design system, which allows users to carve virtual clay.

Industrial Designer Robin Peng is a Freeform™ user and says, "In the past, we conceptualized by creating foam models and mockups, which can be time-consuming. With Freeform™ it's one tenth of the time, and finding optimum proportions is much easier. Once you create a surface digitally, it's not locked in. You generate folders that contain what you like, and if you want to modify the model, you just go to the folders and stick it on." Exemplifying the short learning curve of haptics, Freeform™ unveiled a complex digital carving made by a nine-year-old child with no instruction. How many visual-aural computer interfaces can make that claim?

Yet for haptics researchers, this is not enough. For them, the bounds of the desktop screen are too restrictive.

Beyond the Small Screen

Dr. Srinivasan describes his Holy Grail of Haptics this way: "It will be like a body suit, light and comfortable, that would be able to mimic anything we do in the real world, and more, because it would be under our control. If you have this, applications are wide open." With a haptics suit, even your drafting table would be virtual. Problem is, nobody has been able to figure out how to make such a suit, because, as Dr. Srinivasan puts it, "It seems to violate some of the physical laws." A problem, to be certain, those pesky physical laws, but Dr. Srinivasan and his researchers are undeterred. In the meantime, there is one other important place where you should expect haptics to show up: in the everyday objects of the world around you.

Embedded interfaces are computer feedback devices tucked inside noncomputing devices, like stoves, bathtubs, steering wheels, and clothes. In fact, with haptics almost any object that can be designed can also be a display surface. "You don't think about everything that you touch," S. Joy Mountford points out. "If something can be used as a feedback source, you can use it as an active display surface. The question is, how can you make anything that you interact with more pleasurable and work better?"

Some researchers perceive a growing demand for nondesktop computing, which would free the user to interact with a computer anytime, anywhere, through unconventional interfaces. As part of her research, Karon Maclean, of the University of British Columbia, has studied how haptics can be applied at the consumer level, and her work suggests that a haptic language of sensations could provide instantaneous input and output through any surface that your hands are normally in contact with throughout the day. "What people need is not a gadget but a solution to a problem. The movement is away from desktop computing and into your pocket and in your clothes, so in that case you need a way to interact with it. If you're going to rely on visual feedback, you would need a screen on everything, and that's a nightmare," she says. "Then there's haptics, which gives you simple feedback through forces that tell you something. It's going to be in the walls and on desks and countertops and in clothes."

With embedded haptic interfaces, the technological future could look much less technological, and the term "desktop" could once again refer to the top of an actual desk. With embedded interfaces, design and technology could nudge our attention back toward the actual world.

Design in the Real World

We now spend an enormous amount of time expecting more from our machines and less from our sensory lives. This is because technology tends to exercise only one or two senses at a time, which has the effect of segregating the senses, giving us a specialized, and limited, perspective. Research shows that we trust the sense of sight over the other senses, for instance, and most art, entertainment, and technology reinforce that sensory prejudice. Yet humans are *multivalent*, which is to say a unique combination of all our senses. We must consider what is lost when our most fundamental tools, the senses, lie fallow.

Tactile designer Jon Wippich said, "People can always tell when some thought and handwork has gone into something. That gives it value." Wippich is talking about graphics, but the same could be said of an apple, or the universe we inhabit. If haptics can cause us to reconsider the richness of the actual physical world for even a moment, then technology will have helped us to recall what it is to be human.

The role of design isn't to create meaning, but rather to render meaning apparent. With some careful thought—and design—haptics could help re-stitch our multivalence by directing attention back to a re-integrated perception of the beauty and boundlessness of the tangible: Awe for real clay, real desks, real apples, and the real world.

44 Phases
8444 Wilshire Blvd, 5th floor
Beverly Hills, CA 90211
323-655-6944
www.44phases.com

Ad-Lib Creative
883 Sutter Street
San Francisco, CA 94109
415-345-0955
415-345-0960 fax
www.ad-lib.com

AGF Funds, Inc.
66 Wellington Street West
Toronto Dominion
Bank Tower 31st floor
Toronto, Ontario
M5K1E9
Canada
416-865-4243

Anvil Graphic Design
2611 Broadway
Redwood City, CA 94063
650-261-6090
www.hitanvil.com

Art Center College of
Design, Design Office
1700 Lida Street
Pasadena, CA 91103-1999
626-396-2200

Atelier Für Text Und
Gestaltung
A-6850 Dornbirn Sägerstrabe 4
Dornbirn
Austria
05572/27480

Boxer Design
548 State Street
Brooklyn, NY 11217
718-802-9212
eboxer@thorn.net

Carbone Smolin
Agency
22 W. 19th Street, 10th floor
New York, NY 10011
212-807-0011
212-807-0870 fax
www.carbonesmolin.com

Chen Design
Associates
589 Howard Street, 4th floor
San Francisco, CA 94105-3001
415-896-5338
415-896-5539 fax
www.chendesign.com

Chronicle Books
85 Second Street, 6th floor
San Francisco, CA 94105
415-537-3730
www.chroniclebooks.com

Color Marketing
Group
5904 Richmond Highway, Suite
408
Alexandria, VA 22303
703-329-8500
703-329-0155 fax
cmg@colormarketing.org

Diesel Design
948 Illinois Street, Suite 108
San Francisco, CA 94107
415-621-4481
www.dieseldesign.com

Dotzero Design
8014 SW 6th Avenue
Portland, OR 97219
503-892-9262
503-245-3791 fax
www.Dotzerodesign.com

Carmen Dunjko
41 Shanly Street
Pod_10
Toronto, Ontario
M6H1S2
Canada
416-538-3385

Fame Retail Image
Management
60 South 6th Street, #2600
Minneapolis, MN 55402
612-342-9801

Felder Grafikdesign
Alemannenstrasse 49
A-6830 Rankweil
Austria
0043-0-5522/45002
fax: 0043-0-5522/45020
www.feldergrafik.at

Julie Garcia
812 South Monroe Street
San Jose, CA 95128
408-243-3055
julieg330@aol.com

The Greteman Group
1425 E. Douglas, Suite 200
Wichita, KS 62711
316-263-1004
316-273-1060 fax
www.gretemangroup.com

Gumption Design
60 E. 13th Street, 2E
New York, NY 10003
212-979-8265
212-477-1113 fax
www.gumptiondesign.com

Hornall Anderson
Design Works, Inc.
1008 Western Ave., 6th floor
Seattle WA 98104
206-467-5800
206-467-6411 fax
www.hornallanderson.com

IDEO
700 High Street
Palo Alto, CA 94301
650-289-3409
www.ideo.com

Winnie Li
1029 Doreen Place #4
Venice, CA 90291
winili@earthlink.net

Lippa Pearce Design
Ltd.
358a Richmond Road
Twickenham TW12DU
England
4420 8744 2100
www.lippapearcedesign.com

Margo Chase Design
2255 Bancroft Avenue
Los Angeles, CA 90039
323-668-1055
www.margochase.com

Mark Allen Design
2209 Ocean Avenue
Venice, CA 90291
310-396-6471

MATTER
1614 15th Street, 4th floor
Denver, CO 80202
303-893-0330

Miriello Grafico, Inc.
419 West G Street
San Diego, CA 92101
619-234-1124
www.miriellografico.com

Navy Blue Design
Consultants (London)
Ltd.
Third Floor Morelands 17-21
Old Street
London ECIV 9HL
England
44-207-253-0316
www.navyblue.co.uk

Oh Boy, A Design
Company
49 Geary Street, Suite 530
San Francisco, CA 94108
415-834-9063
www.ohboyco.com

Omatic Design
408 SW 2nd, Suite 509
Portland, OR 97204
503-225-1866
503-225-1846 fax
www.omaticdesign.com

Rebeca Méndez
Communication
Design
2873 N. Mount Curve Avenue
Altadena, CA 91001
626-403-2122
balam@earthlink.net

Jason Ring
200 Bowery, 8E
New York, NY 10012
646-242-7071
718-857-2021 fax

The Riordon Design
Group Inc.
131 George Street
Oakville, Ontario
Canada L6J 3B9
905-339-0750
www.riordondesign.com

Rocketbuster Boots
115 Anthony St,
El Paso, TX 79901-1064
915-541-1300
www.rocketbuster.com

Sagmeister Inc.
222 W 14th Street, #15A,
New York, NY 10011-7226
212-647-1789

Sara Schneider
85 Second Street, 6th floor
San Francisco, CA 94105
415-537-3730

Tracey Shiffman
906 Princeton Street
Santa Monica, CA 90403
310-582-1964

Studio Guarnaccia
31 Fairfield Street
Montclair, NJ 07042
973-746-9785

Unfoldz
(A Division of Darby
Scott Design, Inc.)
8061 Hackberry
Mentor, OH 44060
440-255-3556
440-255-0097 fax
www.unfoldz.com

Vrontikis Design
Office
2707 Westwood Blvd
Los Angeles, CA 90064-4231
310-446-5446

Wen Oliveri
479 Tehama Street
San Francisco, CA 94103
415-284-9807
www.wenoliveri.com

ABOUT THE AUTHORS

Ferdinand Lewis has written about the arts and entertainment for *Daily Variety*, *American Theatre*, *Animation*, *Logik*, *TV Kids*, and *Audio Media* magazines. He is a recipient of an Irvine Fellowship for Arts Journalism, four PBS APAC Awards, the Richard Scott Handley Prize for Creative Writing, the Group Repertory Theatre's New Playwright's Award, and a Durfee Foundation Fellowship.

His plays have been performed on both coasts and in Europe, and his experimental writing has appeared in *Parabasis: The Journal of A.S.K. Theatre Projects*. He is working on a pair of books about ensemble theatre, *Ensemble Works: An Anthology* for Theatre Communications Group Publishers, and *Ensemble Works: Traditions, Approaches, Strategies*, which is supported by the Flintridge Foundation.

Since 1991, Rita Street has written about entertainment, entertainment technology, and the graphic arts for various publications in the U.S., U.K., and Asia. She is the former editor of *Animation* and *Film & Video* magazines. Other Rockport titles authored by Street include *Computer Animation: A Whole New World*, and *Creative Newsletters & Annual Reports: Designing Information*. She is the founder of the international organization, Women In Animation.

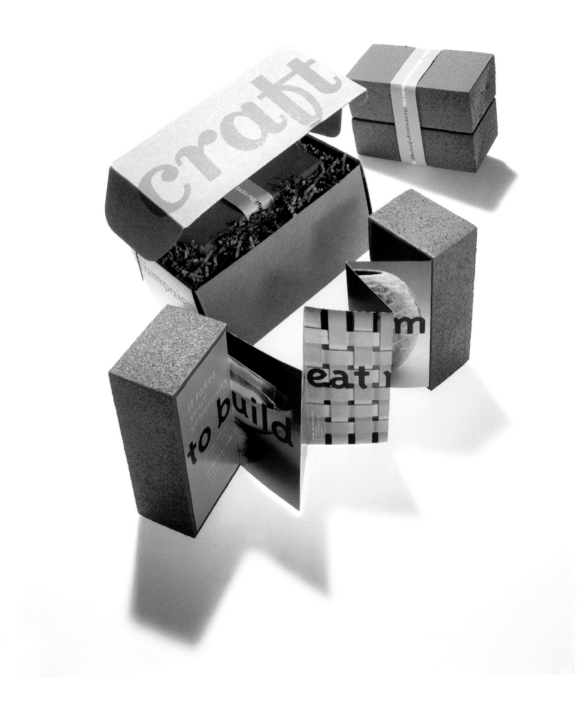